MAIN STREET ARKANSAS

THE HEARTS OF ARKANSAS CITIES AND TOWNS—AS PORTRAYED IN POSTCARDS AND PHOTOGRAPHS

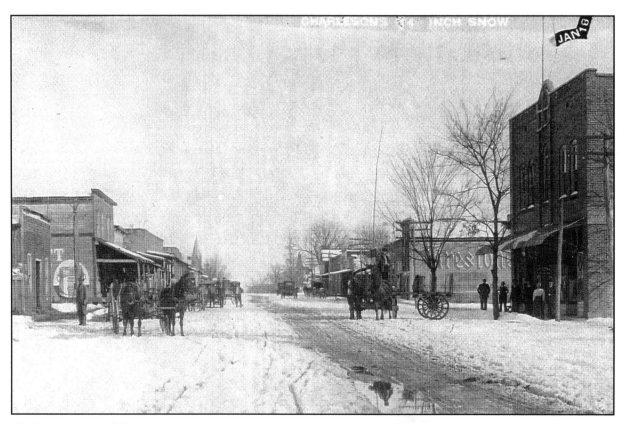

Charleston after snowfall, 1910.

MAIN STREET ARKANSAS

THE HEARTS OF ARKANSAS CITIES AND TOWNS—AS PORTRAYED IN POSTCARDS AND PHOTOGRAPHS

Ray Hanley and Steven Hanley

Butler Center Books

Little Rock, Arkansas

butlercenterbooks.org

Printed in the United States of America

First Edition, 2009

Library of Congress PCN Number: 2009989927

This book is printed on archival-quality paper that meets requirements of the American National Standard for Information Sciences, Permanence of Paper, Printed Library Materials, ANSI Z39.48-1984.

Hardback Edition ISBN 978-1-935106-12-8 [ten-digit: 1-935106-12-0]

HB Printing: 10 9 8 7 6 5 4 3 2 1

Paperback Edition ISBN 978-0-9800897-13-5 [ten-digit: 0-9800897-13-9]

PB Printing: 10 9 8 7 6 5 4 3 2 1

Unless otherwise noted in the caption, all images contained in this book are drawn from the collections of archival photograph-postcards owned by the authors.

Acquired for Butler Center Books by: Rod Lorenzen and Ted Parkhurst
Book cover design: Wendell E. Hall
Page design and composition: Shelly Culbertson
Project manager: Ted Parkhurst

For those pioneer merchants who staked their dreams on the original Main Streets of Arkansas communities, and for those who today seek to preserve that part of our state's heritage.

ACKNOWLEDGEMENTS

THANKS TO: Ted Parkhurst, for sharing the vision in our project.
Brian Robertson of the Butler Center, for always being helpful.
LeMay Photography of Little Rock, for scanning and technical support.

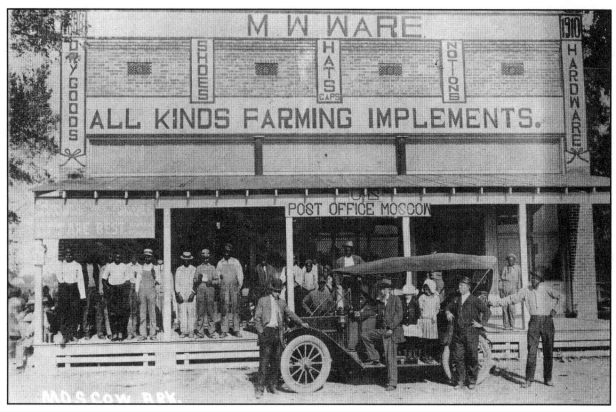

Moscow (Jefferson County) store front, circa 1915.

CONTENTS

INTRODUCTION

"Main Street USA," whether a political phrase, a historical reference, or simply a marketing term, is widely used in the American lexicon. As native Arkansans born in small-town Arkansas in the early 1950s, we have seen over the last few decades a living, vibrant Main Street transform into one that is too often more slogan than reality. The theme of this book is "Main Street Arkansas"—celebrating what that phrase meant through the first half of the twentieth century, exploring what it has become more recently, and offering a hopeful glimpse of what "Main Street" can be in the future. We hope your excursion through these pages will remind you of good memories from another era. Perhaps for younger readers, there will be recognition of cultural strengths and societal transitions throughout Arkansas history—right in their own hometown.

Main Street is the historical root of most Arkansas towns and cities, small or large. Perhaps called Main Street, Broadway, Front Street, or a founder's name, the main streets were the towns' origins. As streets ran outward from that core—here circling courthouse squares, there branching into numbered avenues—the character of architecture evolved, reflecting the era of each new development. Our residential areas grew in the image of their time periods. Nearly everywhere, growth eventually came to include strip malls, shopping centers, and suburbs that drained much vitality from the original street that gave the town its beginning.

The advent of photography in the mid-1800s and certainly the popularity of the picture postcard after 1900 captured much of the evolution of Main Street. What began as rutted dirt paths in front of wood-framed buildings became arteries paved with brick, concrete, and, later, asphalt. Wood-framed shops and commercial buildings of early days yielded to façades of brick and stone or concrete and steel. Unlike in the eastern United States, many of the towns in Arkansas were born at a time when photography was beginning to be widespread. Many Arkansas Main Streets were captured in visual images from their first wood-framed store fronts facing out onto train tracks and rough dirt streets.

Most of the images that fill this book come from a personal collection of Arkansas postcards assembled over 30 years. A few others, as noted, come from public archives. We have learned that

picture postcards offer a unique window into the past that the sometimes sterile photographs in history books do not. Very often, the postcard of Main Street in Little Rock, Morrilton, or Lake Village from a century ago was held in the hands of a person who walked that street, saw the actual sights, and sometimes even penciled or penned their impressions.

Far too many Arkansas "downtowns" are today home to empty concrete slabs, or to ghostly empty storefronts, windows to the not-so-distant past when the city center was the pride of the community and worth putting onto postcards that visitors would mail home with perhaps "Wish you were here" inscribed on the back. Too many of the once vibrant business blocks of what were often family-owned or franchised stores have been replaced by "big box stores" on the edge of town, boxes that resemble, even identically mirror, the same boxes on the outskirts of hundreds of other American towns. We hope that this book will help you recall or imagine the hearts of Arkansas towns in days past, hearts that today are receiving much-needed life blood from community improvement groups, architectural preservationists, and those who celebrate the character of structures that reflect an earlier era.

To complete this book, we visited—actually re-visited—the streets whose images are found in these pages. A view can change rapidly. What stood on a corner just five years ago can today be a burned-out shell, a parking lot, or perhaps an instant outpost of some chain that discerns no difference in the hearts of Bald Knob, Arkansas, and Poughkeepsie, New York.

It would be impossible to write a book on Arkansas Main Streets without some reference to Wal-Mart, the largest corporation in the world, at least in terms of employees. It would have been redundant to say, quite accurately, in many of the captions in this book that "the retail business left Main Street years ago and is today clustered around Wal-Mart on the edge of town." Yes, the erection of a nearby Wal-Mart certainly has been a major marker of the decline of many Arkansas towns' central business districts. However, we believe one can acknowledge this fact without demonizing Wal-Mart. The truth is that Sam Walton's vision, his business model, is American capitalism at its heart. He saw a market in small towns and remote areas and built his discount stores ahead of competitors. KMart and others were too late to see the bonanza Sam Walton perceived. Americans voted with their feet (and their cash and credit cards), and Arkansas-based Wal-Mart grew into the world's largest retailer.

The challenge for many towns—with the help of governmental units like the Main Street Arkansas program of the Department of Arkansas Heritage, civic leaders, corporations (including Wal-Mart), and citizens—is to find value in restoring and preserving their downtowns. In our

research for this book, we saw both the ideal models and the sad faces of failure on Main Street. Standout model projects certainly include Siloam Springs, El Dorado, Searcy, and Nashville. Their citizens have kept or returned vitality to their downtowns. In our travels, we found what had once been downtown McGehee literally gone. In contrast—just a short drive down Highway 65— we found a nicely intact Dumas downtown. Hanging dangerously in the balance are Main Streets in towns such as Wynne, Forrest City, and Harrisburg.

We hope you will discover something of your favorite Arkansas hometown—relive the pleasant memory of shopping, dining, or perhaps joining a throng to watch a passing parade on the blocks pictured in these pages. Maybe you will recall a favorite store, now closed, or the friendly face of a merchant who remembered your shoe size or favorite soda-fountain flavor. Whatever your reason to peruse these pages, we trust you join us in celebrating the evolving spirit of our state and its communities. We hope as well to inspire you to look for ways to get involved in organizations committed to restoring and maintaining the viability of "Main Street Arkansas."

CENTRAL ARKANSAS

Little Rock anchors the middle of the state. A collage of small-towns-grown-large surrounds the capital city. Also, there are those towns whose destiny—usually decided by random forces like the bend of a river or the path chosen by a railroad survey—was to remain small. Regardless of size, each community has ingrained in its history a Main Street story well worth the effort to seek out and preserve.

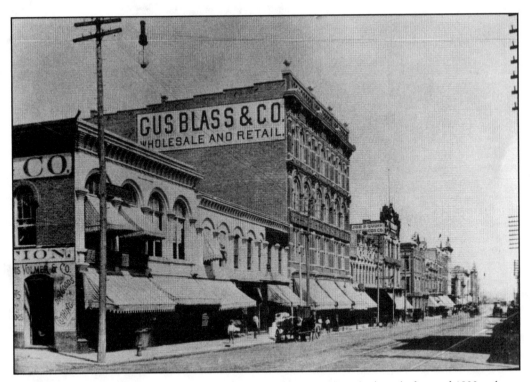

Little Rock, circa 1900 The east side of the 300 block of Main Street was photographed around 1900, only a few short blocks from the "little rock" that gave the city its name. Most prominent is the department store of pioneer merchant Gus Blass. Struck by two fires, the last in 1916, the block has largely survived, although with altered façades and much in need of restoration and revival. *(Photo courtesy of the Butler Center for Arkansas Studies)*

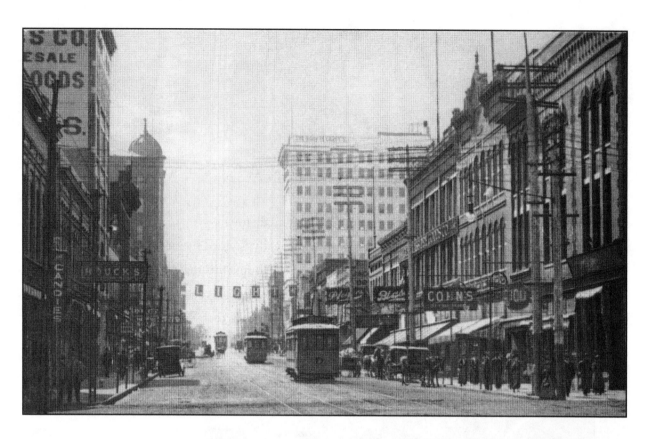

Little Rock, circa 1910 and 1940
The circa 1910 postcard (above) looks up the west side of the 300 block of Little Rock's Main Street. A steady stream of streetcars was poised to pass pioneer merchants M. M. Cohn's, Blass, and Pfeifer's department stores. The then-new State National Bank (today's Boyle Building) rises in the distance across from the domed Masonic Temple. The same block is seen (right) in the 1940s, largely intact with Blass having replaced its store just to the left. Stein's men's clothing store at the corner of 3rd is today home to Bennett's Military Supply store. The Cohn's building would be torn down in favor of a new flagship store in the 1940s.

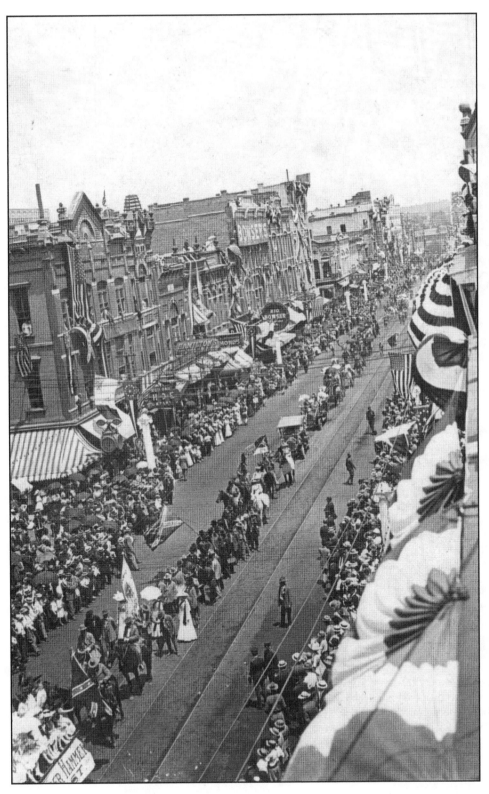

Little Rock, 1911
For three days in May of 1911, the 45,000 residents of Little Rock shared their Main Street with 100,000 visitors who attended the annual reunion of the United Confederate Veterans, an elderly army 12,000 strong. The event concluded with a parade that took two hours to pass any one point, seen here looking north from 5th & Main. The photographer was apparently standing atop the building that today houses the Arkansas Repertory Theater. Much of what was in the lens, sadly, is gone today.

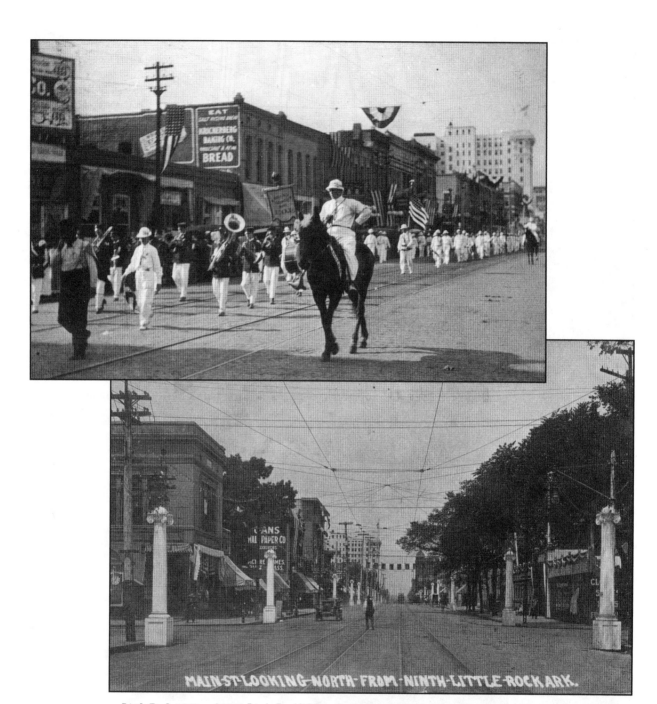

MAIN ST LOOKING NORTH FROM NINTH LITTLE ROCK ARK.

Little Rock, 1910 and 1911 Little Rock's Main Street parades brought out the photographers, and one was at work above as the Elk's Lodge band marched by the 800 block, which today is a parking lot. Farther south, looking north from 9th Street down Main, plaster columns were erected to hang lights for the United Confederate Veterans Reunion, hosted over three days by Little Rock. To the right, the Airdome Summer Theater hosted plays, while to the left are Rossi's Café and a wallpaper store. Today, little more than the distant Boyle Building remains.

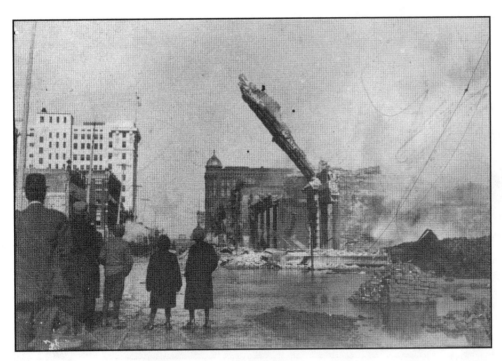

Little Rock, 1911
The city's Main Street has suffered greatly over the decades from fire. A carelessly discarded cigarette by a night janitor in a music store in 1911 ignited a fire that would wipe out most of the east side of the 600 block of Little Rock's Main Street. The next morning, an alert photographer captured the last brick wall toppling over onto the street.

North Little Rock, 1927 A victim not of fire but water, North Little Rock's Main Street, not nearly as photographed through the years as its larger neighbor, did draw photographers when inundated by the great flood of 1927. Today, the street is restored, with fine dining on the bustling north shore of the Arkansas River.

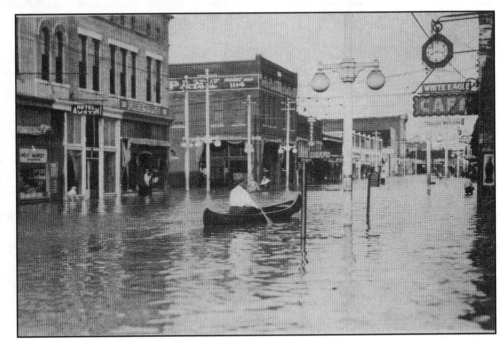

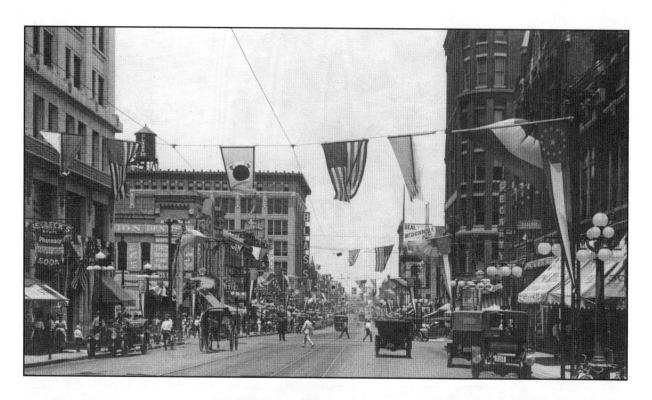

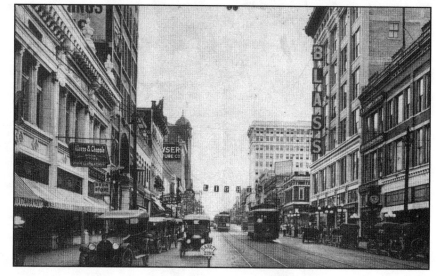

Little Rock, circa 1918

The creation of Camp Pike on the north shore of the Arkansas River during World War I brought thousands of troops for training, helping Little Rock's Main Street boom. The horse and buggy had just passed the intersection of Capitol & Main, heading south. The two-story building just beyond (today a vacant lot) housed Union Dentists, advertising a set of teeth for $5 and "teeth extracted without pain." The dental clinic building was gone by the 1940s, and the rest of the block was razed in 2009. The towering Masonic temple to the right would burn in 1920, the State National Bank (Boyle Building) to the left still stands. The 300 block of Main (right) saw its share of prosperity around 1918, with Blass department store to the right, and landmark Allsopp & Chapple's Book Store to the left. The store is long gone, but the handsome Rose Building still survives, though vacant.

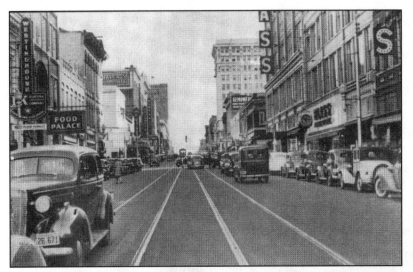

Little Rock, circa 1945, World War II
Nearby Camp Robinson helped keep Little Rock's Main Street packed. Notice Blass department store to the right, Kempner's a block up, and the Food Palace on the left. Automobile traffic was beginning to crowd the streetcars, one of which can be seen in the distance. The end of the war brought a Little Rock victory parade (below), with soldiers and their armaments passing the 200 block of Main heading north toward a banner reading, "Welcome Home Soldiers." At the time, the block had two movie houses, the Roxy and the air-conditioned Rex; between the theaters was Farrior's Army Store. The Wallace Building towers in the left corner of the photo.

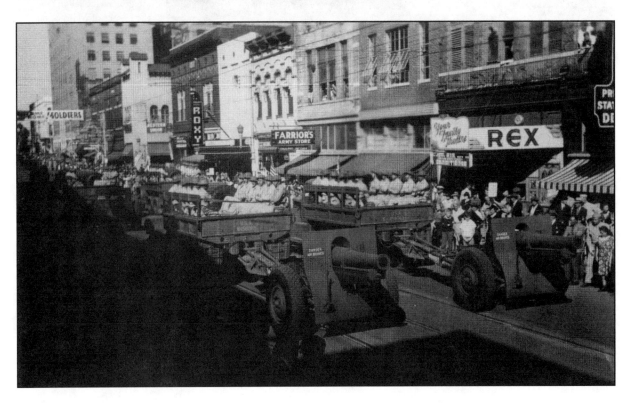

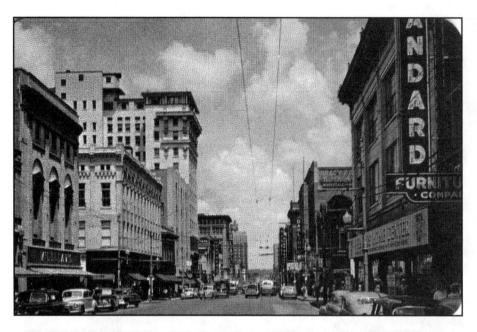

Little Rock, early 1950s
By the early 1950s, streetcars had disappeared from Little Rock streets, replaced by buses. The first outlying shopping center was still a few years away, and Main Street remained the city's heart, with Standard Furniture (today's Repertory Theater), Haverty's, Kempner's, Blass, M. M. Cohn's, Baker's and Butler's family-owned shoe stores, and Stifft's jewelry. Most of the buildings still stand today, though the retailers are gone. McClellan's on the corner of Main & 6th above is now a parking lot. Exchange Bank, which failed during the Depression, is visible just up from Haverty's. It replaced the Masonic Temple in the late 1920s.

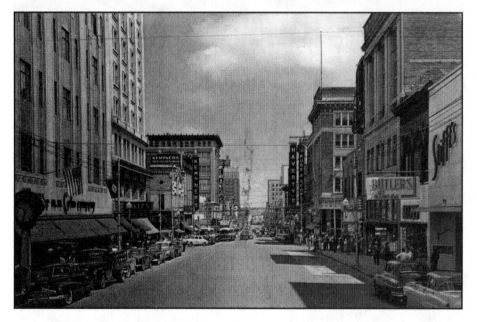

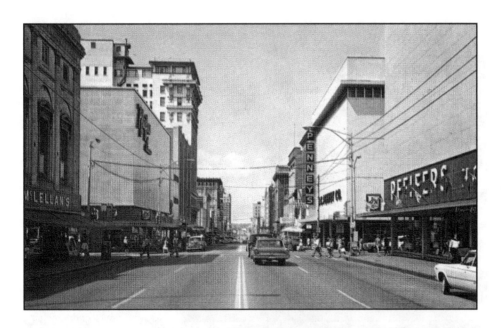

Little Rock, late 1950s
Park Plaza Shopping Center
was rising on the western
edge of town, but Main
Street was still home to most
retail activity. Woolworth's
and Blass department stores
are seen, with Worthen
Bank just to the right at
4th & Main. Today, the old
Worthen Bank building is
home to KATV. The Grady
Manning Hotel towers at
the north end of Main Street.
The Little Rock Convention
Center now stands where
the Grady Manning and
Marion hotels once stood.
Pfeifer's occupied both sides
of the street, promising S&H
Green Stamps. The company
covered the buildings with
a siding material which
today has been removed. The
Repertory Theater occupies
the former store on the right.
A block down is J.C. Penney,
converted to a mall project
in the 1980s, one that proved
to have but a short life. The
Woolworth's building was
razed in 2009.

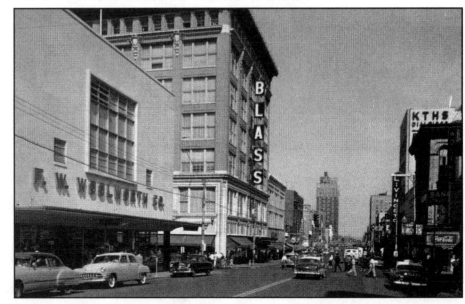

Little Rock, circa 1955
Well into the 1950s, especially on Friday nights, the stores on Little Rock's Main Street remained open late, and the neon lit up the darkness. Haverty's, Kempner's, and the other merchants might have tempted shoppers who later watched William Holden star as an air force test pilot in *The Unknown* at the Center Theater. Today, the retailers are all gone and the Center, built in 1912, is slated to be demolished.

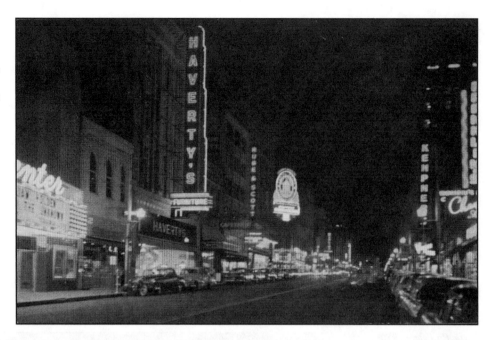

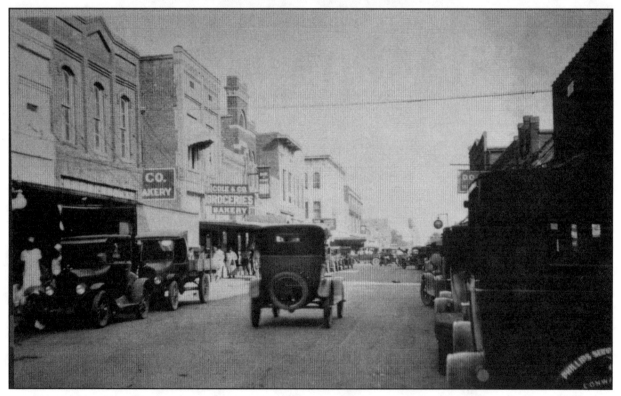

Conway, circa 1920 While Little Rock grew, the small college town and Faulkner County seat had its own bustling downtown packed with commerce, including Cole & Co. Groceries & Bakery to the left. Conway has done a commendable job of downtown revitalization in recent years.

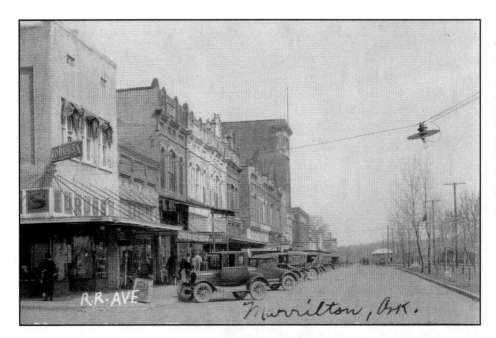

Morrilton, circa 1925
During the prosperous 1920s, the town—named for its founders, E. J. and George Morrill—found its Railroad Avenue lined with automobiles, mostly Ford Model-Ts. Destinations included the corner drug store, a meat market, a grocery, and Warren's Café in the block shown in the top photo.

Morrilton, circa 1940
The same block is seen in the 1940s: the corner still a drug store, Kroger occupying the adjacent grocery store, and once-familiar names like Western Auto and Rexall drugs sharing more of the block with still-operating Warren's Café. *(Photo courtesy of the Butler Center for Arkansas Studies)*

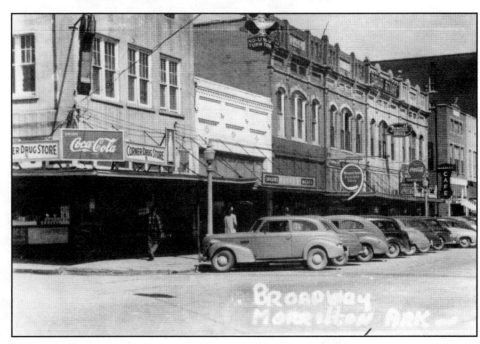

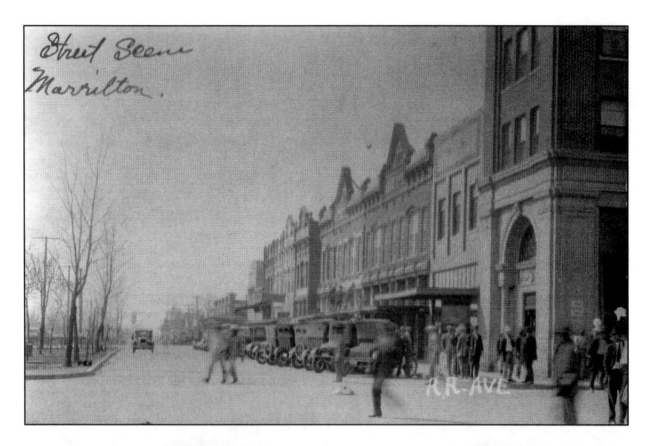

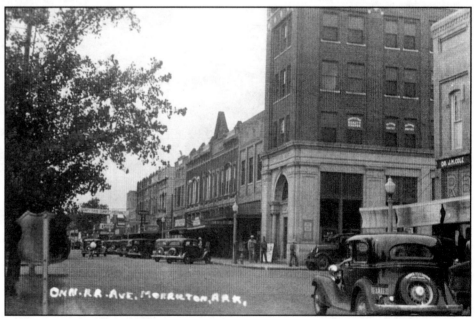

Morrilton, circa 1920 and 1940 Farther north on the same block of Morrilton's Railroad Avenue was the First National Bank, the town's tallest building, dominating its corner. By the early 1940s, U.S. Highway 64 went down Morrilton's Railroad Avenue, bringing the era's larger automobiles past buildings dating from the horse-and-buggy era. The train tracks that engendered the founding of the town are just out of sight to the left.

Morrilton, 2009 A leap through time to the same corner of Railroad Avenue seen on the opposite page offers a stark contrast. Most buildings still stand, but with distinct rooftop features gone, and some covered with aluminum and other types of siding, a common occurrence in a number of downtowns beginning in the 1960s.

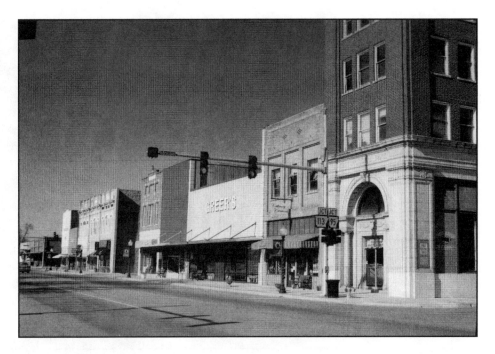

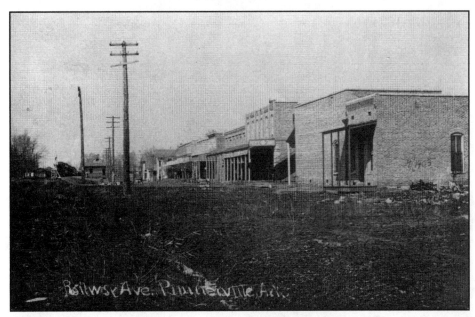

Plumerville, 1908 This small Conway County village was named for an early settler from Massachusetts, Samuel Plummer. A century ago, its brick business district faced dirt-packed Railway Avenue and the tracks. Today, no trace of the buildings remains; the only retailers in Plumerville are convenience stores along Highway 64.

Benton, circa 1910
As the Saline County seat, Benton boasted a downtown business district that just naturally clustered around the courthouse square. Among its merchants was the Hughes & McCray general store, whose owners and employees posed in front of the store.

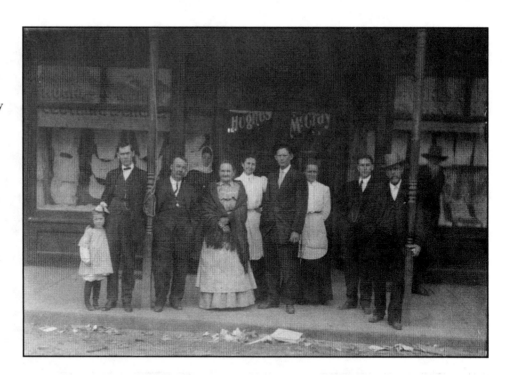

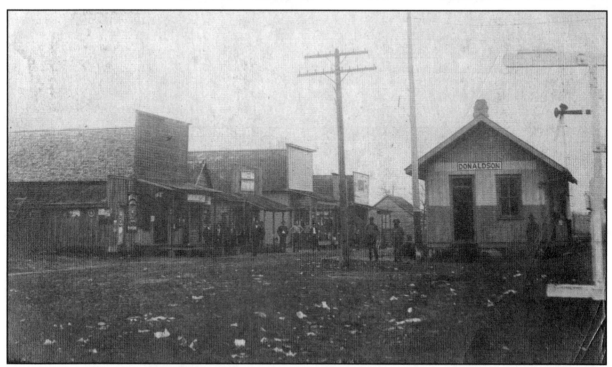

Donaldson, 1908 The small Hot Spring County railroad and farming community clustered its rough wood-framed Main Street opposite the tracks and depot. Today, the buildings are gone, their replacements almost unnoticed below a 1930s-era Highway 67 viaduct.

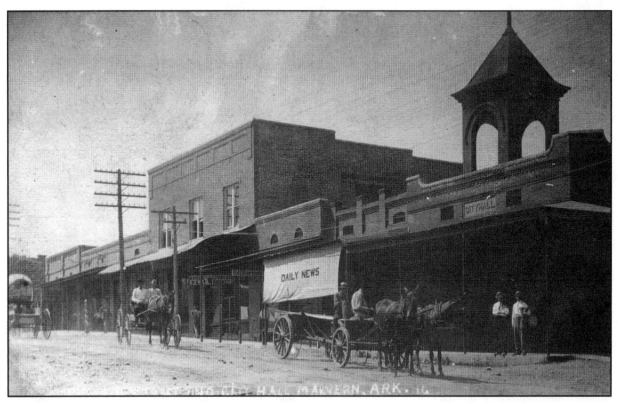

Malvern, circa 1905 Platted by railroad surveyors in 1873, the Hot Spring County seat had by 1905 a wide Main Street—still dirt. Visible on the block behind the wagon traffic are a barber shop, Baker's Meat Market, the *Daily News office,* and, beneath the arched tower, City Hall. The buildings no longer stand.

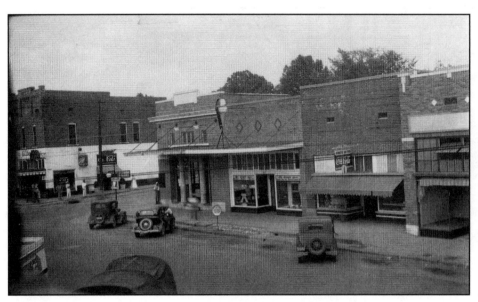

Malvern, 1934
Main Street was paved and served as the center of retail by 1934 when this photo was taken. The Elite Café to the far left competed for business with the Bright Spot in the center of the block, where front-door parking was reserved for curb service.

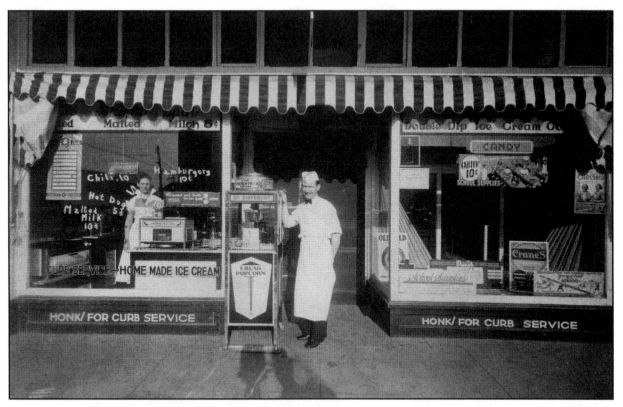

Malvern, 1934 The proprietor of the Bright Spot, a café shown on the previous page, posed with his popcorn machine. Hot dogs were five cents; hamburgers and malted milks were a dime. The business also sold school supplies and hosted a dance hall on the second floor. Though altered, the block still stands.

Malvern, 1950s
The 1950s found Malvern's Main Street home to almost all the town's retailers, even Padgett's Chevrolet dealership. Today, a number of the buildings are either gone or vacant; most retail businesses have relocated around Wal-Mart, west of Malvern along I-30.

Cabot, circa 1910
Main Street's sturdy brick buildings faced a rough dirt path but housed businesses such as a barber shop and Jolly Brothers store. No trace remains today of these buildings in a town that has grown rapidly in recent years as a bedroom community to Little Rock.

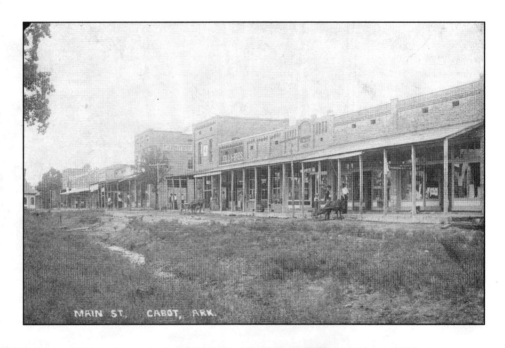

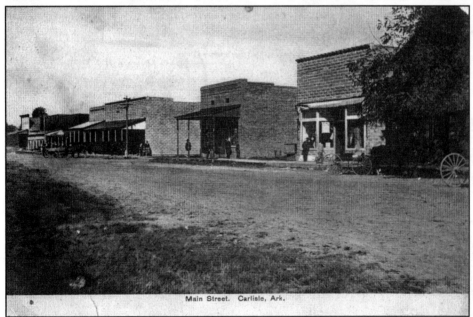

Carlisle, 1909
This small Lonoke County farming town's Main Street remains largely intact a century after its stores were erected. Today, the center building houses a nursing home office. A new police department has been built in the gap between buildings.

Lonoke, 1908 and circa 1975 Anchor businesses settled on Front Street, a portion of which is shown here in 1908 where the furniture store "sold for less" next to a sturdy stone bank building (with the arched door). The same street, seen below in the 1970s, was home to once well-known retailers such as Sterling and OTASCO. Today, those buildings survive, but most of the shopping occurs around Wal-Mart north of downtown.

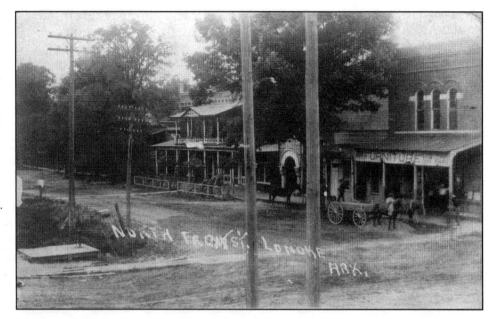

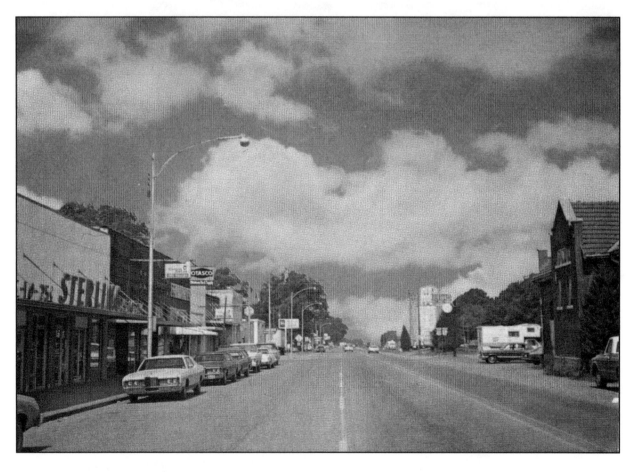

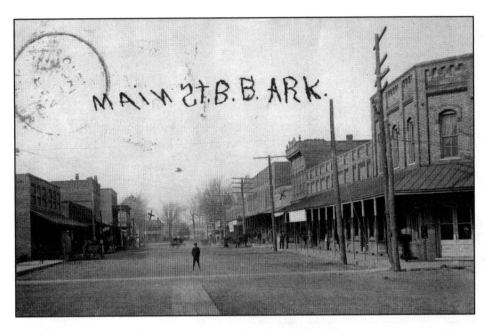

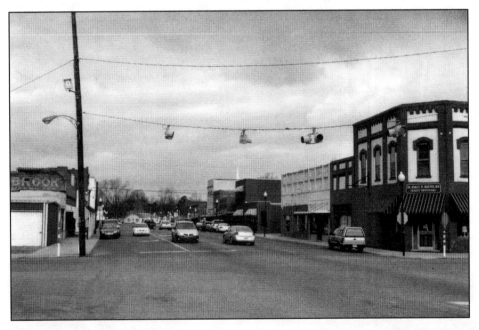

Beebe, circa 1910 and 2009 The White County community was established in 1872 when merchants moved their stores five miles east from the 1849 post office settlement of Stoney Point to a stop on the Cairo and Fulton Railroad. The town, incorporated in 1875, was named for Roswell Beebe, who had been the railway's first president. A handwritten message reads, "The house I have marked is where Bea lives and the other building marked is the bank where George works." The building on the corner was also a bank, thus the small town had two financial institutions. Today (bottom photo), the corner location is a dentist's office and the other bank building is gone. The lot where the house stood is now a church parking lot. Most other surviving buildings are occupied and well maintained.

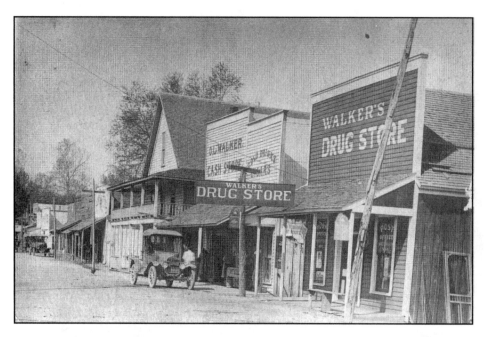

Higginson, 1923
Most of the businesses in this once-vibrant White County village a few miles east of Searcy were owned by O. L. Walker. No trace of the buildings remains today.

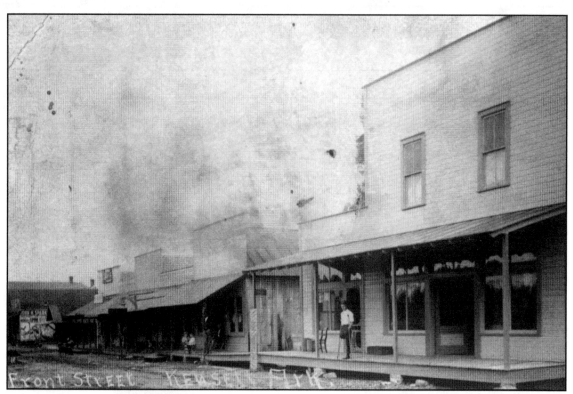

Kensett, circa 1910 The tiny White County town, best known for being the home of Congressman Wilbur Mills, centered its commerce along Front Street, where the boy stands. One wonders how his leg was lost. No trace of the frame buildings remains. *(Photo courtesy of the Butler Center for Arkansas Studies)*

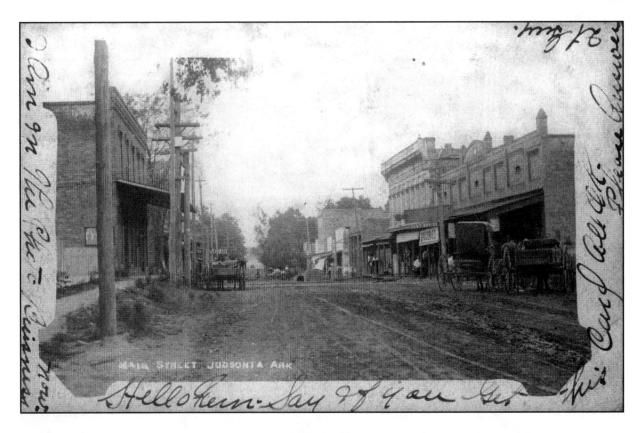

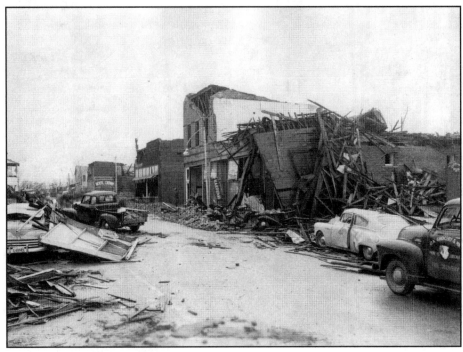

Judsonia, 1907 and 1952

Originally a riverboat port on the Little Red River called Prospect Bluff, the town was renamed Judsonia after the Civil War. "I'm in the photo business now" was the message of the photographer who put the small White County town's Main Street on a postcard a century ago. In the top photo, discernable signs show two grocery stores and the post office in the center of the block to the right. The bottom photo shows the effects of a 1952 tornado that killed 30 residents and destroyed 385 homes along with the entire business district.

Searcy, 1908 and 1958
The White County seat's business district is seen in images 50 years apart. Searcy grew steadily after World War II, with businessmen leading an effort to attract industry. The International Shoe Company of St. Louis, Missouri, started production in 1947, with other industries following. Ray Yarnell had started Yarnell's Ice Cream Company in Searcy in 1933, which is today the only ice cream manufacturer based in Arkansas. The Ben Franklin store shown in the bottom photo is long gone, but the downtown is today nicely intact and prosperously occupied.

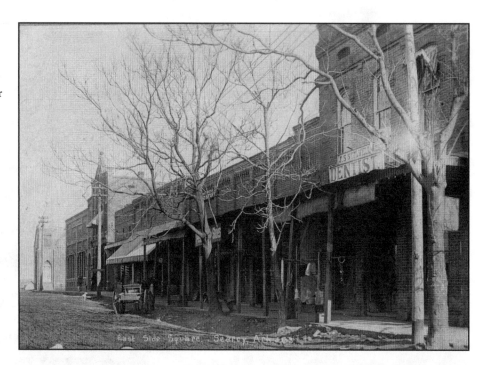

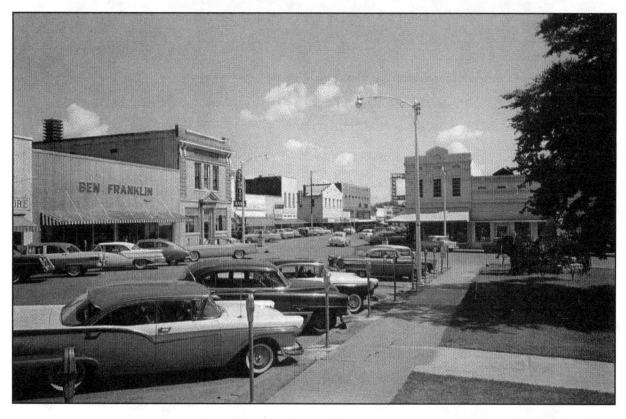

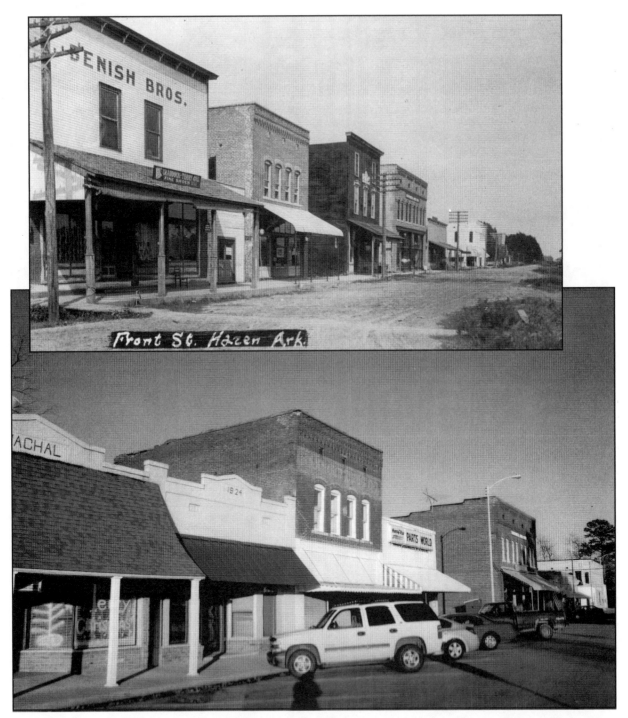

Hazen, circa 1909 and 2009 Dr. W. C. Hazen brought his family and slaves to settle the area in 1854. Nineteen years later, the community that sprang up along the railroad there took his name. This Prairie County farming town has changed less in a century than most. Many frame buildings—like the one housing Benish Brothers store—are gone, but others remain today.

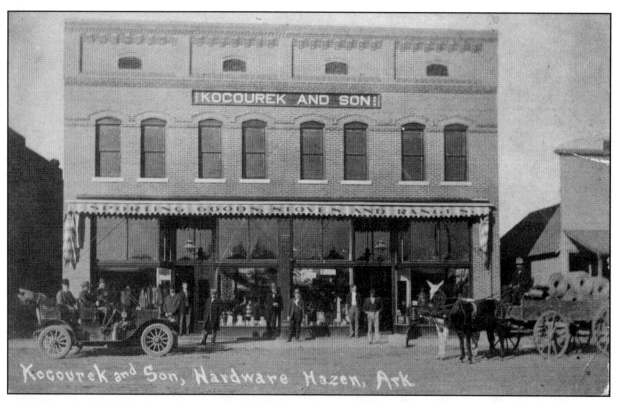

KOCOUREK AND SON

SPORTING GOODS, STOVES AND RANGES

Kocourek and Son, Hardware Hazen, Ark.

Hazen, circa 1912 Kocourek and Son sold hardware and sporting goods on Front Street for almost a century before closing a few years ago. Today, the nicely restored building is home to an antique store.

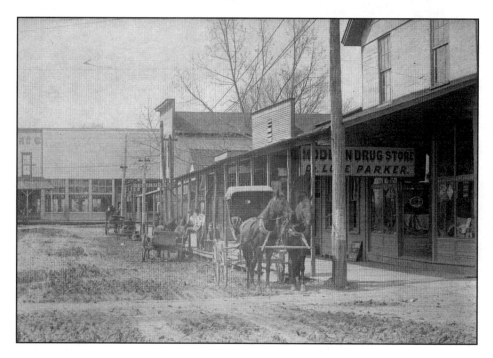

MODERN DRUG STORE
DR. L. E. PARKER.

DeValls Bluff, circa 1910 The Prairie County town, reportedly named for a Frenchman, shared county seat honors with Des Arc and saw its business district develop around the courthouse. Most prominent in this photo is Dr. Parker's Modern Drug Store. All of the frame structures are gone today.

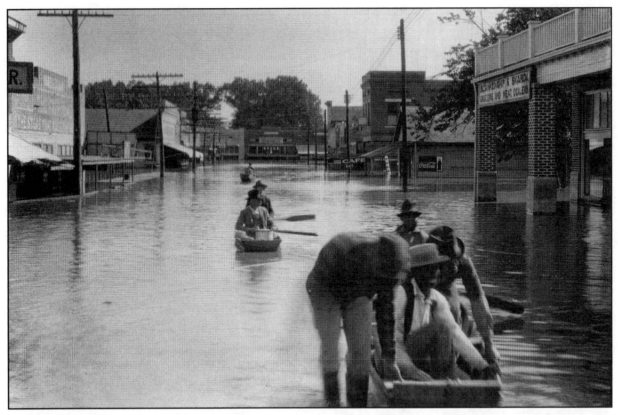

DeValls Bluff, 1927 The town's location on the White River necessitated boats on the main street during the worst flood in Arkansas history. The Castleberry hotel to the right and other buildings still stand. U.S. Highway 70 passes over the route today.

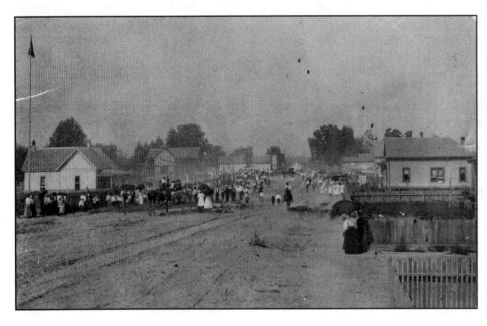

Leola, 1908 This tiny Grant County town's dusty Main Street saw most of its citizens come out for a Confederate veterans parade.

Bigelow, circa 1910
The northeast Perry County logging town's main street was short and rough. The general store behind these area residents was plastered with ads for laxatives and liver pills, likely sold inside.

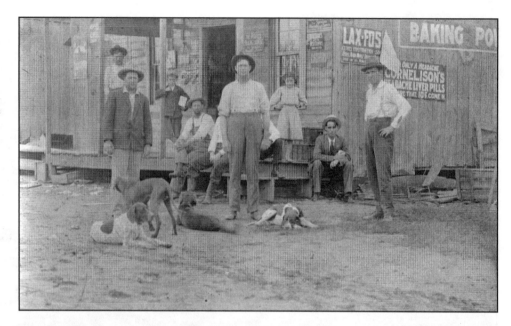

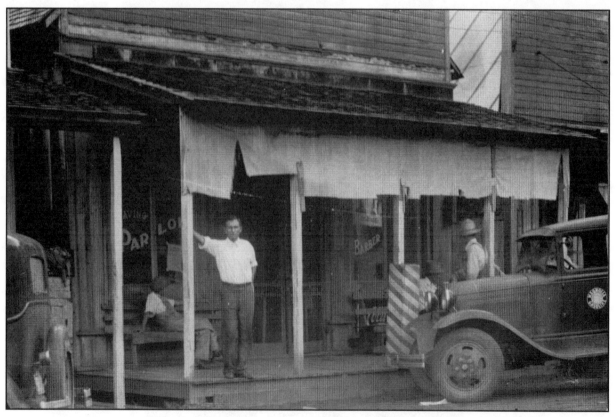

Perry, 1932 The northwest Perry County village (like the county) was named for Admiral Oliver Perry, naval hero of the War of 1812. During the Great Depression, its main street was home to a shaving parlor and barber shop.

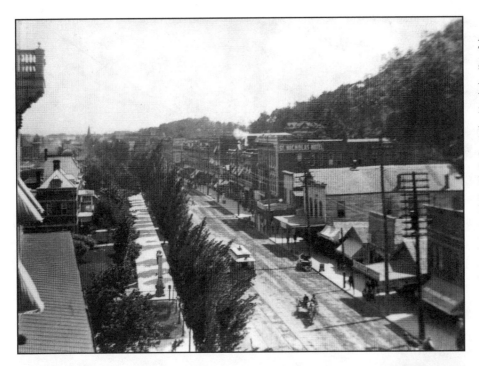

Hot Springs, circa 1895
The famed resort's main street was and is Central Avenue. The photo here was taken looking south from a balcony of the Arlington Hotel, already the queen of the walk during the "gay nineties." Central Avenue was yet to be paved but already had streetcars. Then-prosperous bath houses line the east (left in this photo) side of Central, and commercial businesses are seen along the west (right) side of the busy thoroughfare.

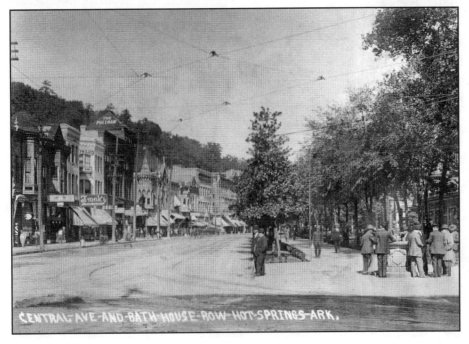

CENTRAL AVE AND BATH HOUSE ROW HOT SPRINGS ARK.

Hot Springs, 1910 Central Avenue was lined on the west side with small hotels, rooming houses, and shops, while to the right, the lower end of Bath House Row is seen in this view. Note the public fountain dispensing thermal water for drinking. Although this particular fountain was removed years ago, others replaced it, allowing tourists from every state and many other countries to partake of the mineral waters. Now many of the commercial buildings are either gone or altered, while the bath houses of the era were later replaced with more substantial buildings.

Hot Springs, circa 1911
Even a century ago, Central Avenue catered to tourists. Visitors then might well have taken in a silent film for 10 cents at the Lyceum theater, dined next door at Frisby's Café, and found lodging just beyond at the budget-class Eddy Hotel.

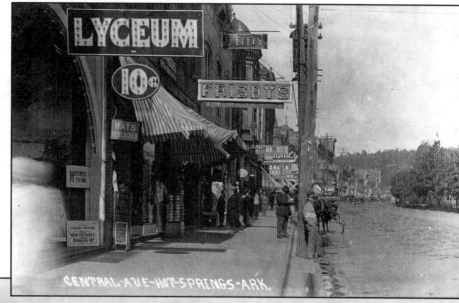

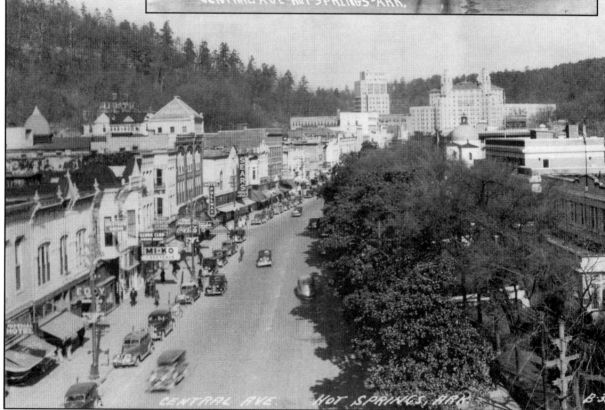

Hot Springs, circa 1935 Retailers on the west side of Central Avenue (on the left in this view) included Sears, and they shared the district with economy hotels such as the Eddy and the Imperial. Tourists visited the Ozark Club above the Miko Cafeteria. Looming in the distance is the Arlington Hotel. Sears and other major retailers abandoned downtown during the 1970s for outlying shopping centers and were replaced a decade or two later by art galleries, fine restaurants, and gift shops.

NORTHEAST ARKANSAS

Bountiful Arkansas Delta fields, verdant with rice, soybeans, and other crops, form much of the backdrop for the cities and villages of northeast Arkansas. In some areas, Crowley's Ridge and the eastern foothills of the Ozark Mountains offer a hint of the state's geographical diversity. Timber provided the region's first economic boom and was followed by farming, river commerce, tourism, and, later, small manufacturing. Through the decades, diverse economies helped shape some of the most interesting Main Streets in the state.

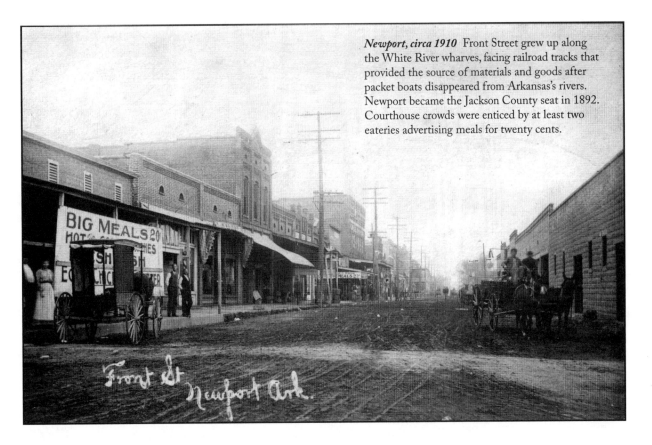

Newport, circa 1910 Front Street grew up along the White River wharves, facing railroad tracks that provided the source of materials and goods after packet boats disappeared from Arkansas's rivers. Newport became the Jackson County seat in 1892. Courthouse crowds were enticed by at least two eateries advertising meals for twenty cents.

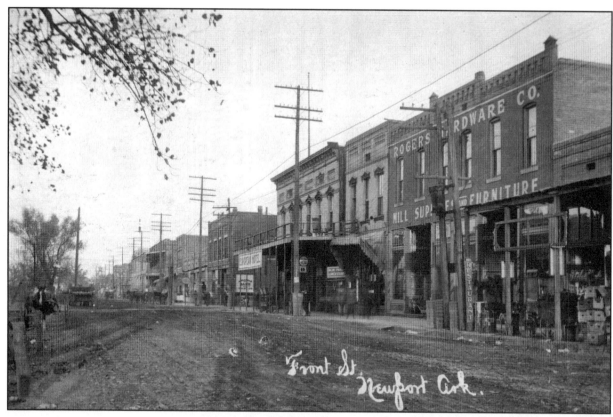

Newport, circa 1910
Tradition has it that the town of Newport was named to distinguish it from the "old" port, nearby Jacksonport (now a state park featuring an ornate 1869 courthouse). Front Street was home to a variety of commercial enterprises a century ago, including the Rogers Hardware Co., European Hotel, Arkansas Bank and Trust, and the Blue Front Lunchroom.

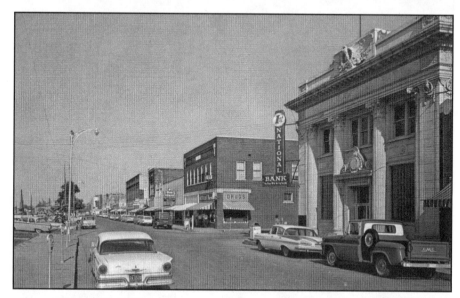

Newport, circa 1960 Parking spaces were at a premium on Saturdays in an era of tail-fin cars and a downtown that was still the place to shop. Most of the buildings still stand today although many are vacant and in disrepair. The Rexall Drug building is now a vacant slab, and even the stately building that was once home to First National Bank is empty.

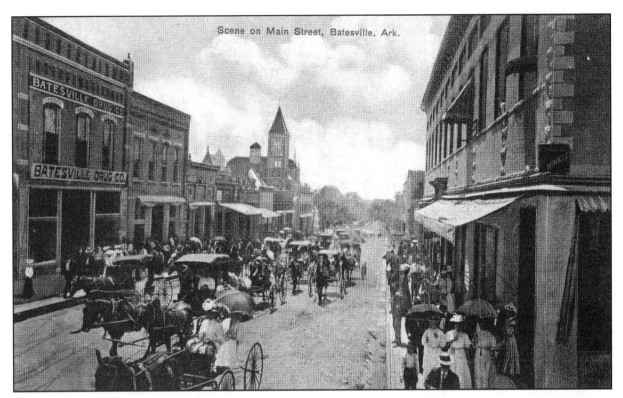

Scene on Main Street, Batesville, Ark.

Batesville, circa 1905 Among the state's most historic Main Streets is that of the Independence County seat, founded in 1820. Batesville is Arkansas's second-oldest city, second only to Georgetown in White County, which is the oldest continuously settled community, having been founded in 1789. On a hot summer day a century ago, ladies walked the still-dirt street under the shade of umbrellas.

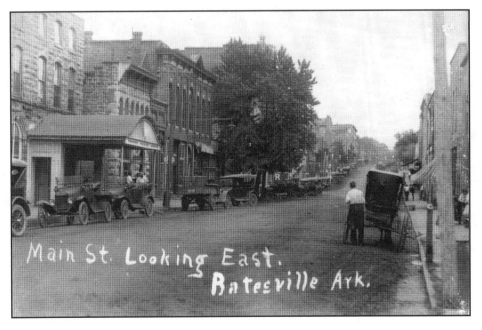

Main St. Looking East. Batesville Ark.

Batesville, circa 1915 In this view, a man peeks around a buggy, looking up the dirt Main Street in an era when the automobile was replacing horse-drawn conveyances like his. Today, much of the street's century-old buildings remain, though the one to the immediate left is gone, as is the Independence County Courthouse towering in the distance.

Batesville, circa 1955
Main Street was home to several movie theaters, including the Melba, which opened in 1940 in a building erected in 1875. The oldest operating movie house in the state, it is still showing first-run movies today. The large building next door, with Western Union on the ground floor, has been lost to the ravages of time.

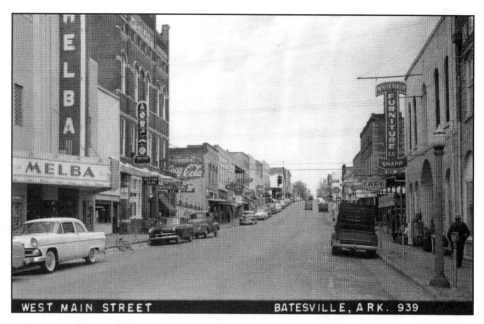

WEST MAIN STREET BATESVILLE, ARK. 939

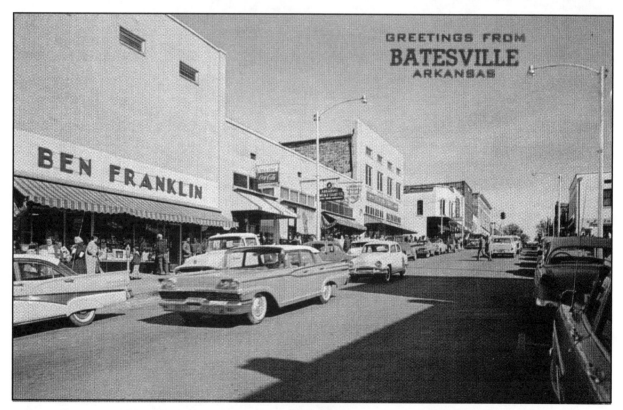

Batesville, circa 1957 Main Street was still a place of numerous shopping choices, including mainstays like Ben Franklin and, farther up the street, Sterling. Next to Ben Franklin was Doc's Café and the local office of Arkansas Power & Light.

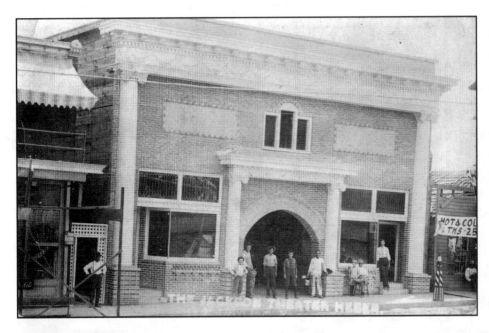

Heber Springs, circa 1917
By the second decade of the twentieth century, the Cleburne County resort town boasted two theaters on Main Street showing silent films and plays. The Jackson Theater (left) was an elegant opera house with carpets and plush seats, in some contrast to the business next door advertising hot and cold baths for 25 cents. The Olympia Airdome (bottom photo) promised "Ladies Rest Rooms" and featured a Western film on one of its posters. Both theaters were gone by the 1930s.

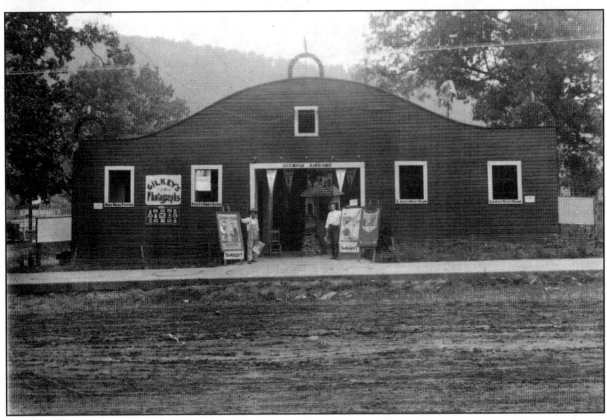

43

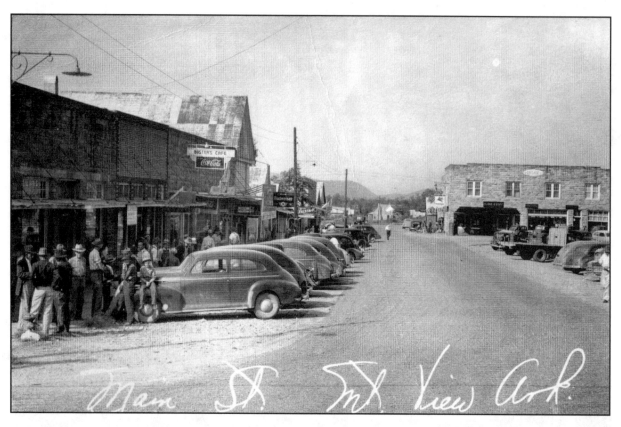

Main St. Mt. View Ark.

Mountain View, circa 1950
The Stone County seat's Main Street packed its commerce into just a few short blocks. One block (above) was home to Buster's Café. Farther down the street, Falstaff and Budweiser signs marked taverns. Mountain View residents could have shopped at Western Auto or taken in a movie at the Stone Theater, shown in the photo on the right. While much of the commerce has moved to the edge of town in modern times, most of the buildings remain.

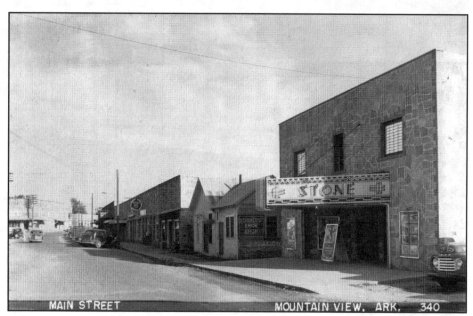

MAIN STREET MOUNTAIN VIEW, ARK. 340

44

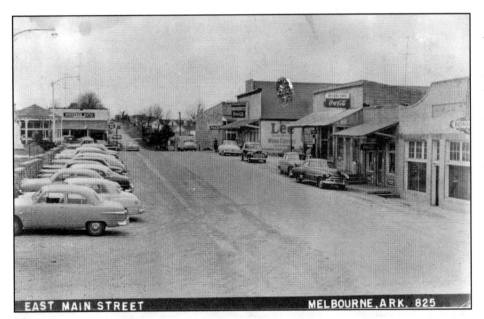

EAST MAIN STREET MELBOURNE, ARK. 825

Melbourne, circa 1950
East Main Street runs in front of the Izard County Courthouse, just out of view to the left. Today, the center building in this view, where the De-Luxe Café fed visitors, still stands, but the Plymouth dealership and buildings farther up the street have been replaced.

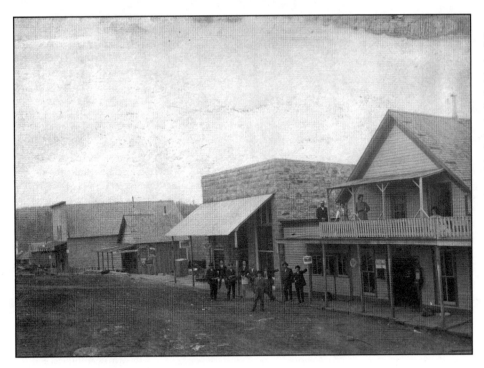

Calico Rock, 1909
Traveling by canoe in 1819, New York native Henry Schoolcraft noted the unusual coloration of the limestone bluffs above the White River, denoting their mixed coloring as "Calico," hence the name later taken by the Sharp County town. The writer of the card, in his message to someone in Illinois, penciled "a view up Main Street from near the river showing the east side of street."

Calico Rock, 1940 By the end of the Depression, Main Street was still unpaved, but motorists came to town on Saturdays to shop at merchants like Floyd's Grocery on the right. A hotel sign can be seen across the street. The town's remarkably intact vintage buildings drew Howard B. Pierce, a prolific producer of "B-movies," to the area in 1974 to film the Prohibition-inspired movie, *The Bootleggers.*

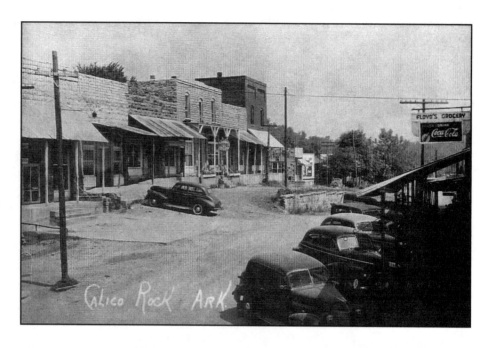

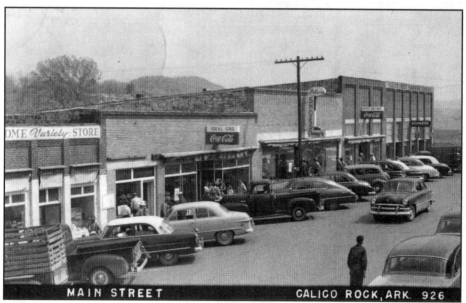

Calico Rock, 1955 The gaggle of shoppers on Main Street suggests that the photo was taken on a Saturday, the day local farmers brought entire families to town and also the day of heaviest traffic for weekend fishermen, hunters, and picnicking families escaping Little Rock's summer heat. It was a busy day at Ideal Grocery, Peter's Shoes, and Floyd's Grocery (the latter of which was in business in the photo above in 1940). Today, the entire downtown is on the National Register of Historic Places. The building that once housed Ideal Grocery is now home to Erma's Antiques, and the building at the end of the street now houses Don Quixote's Calico Kitchen.

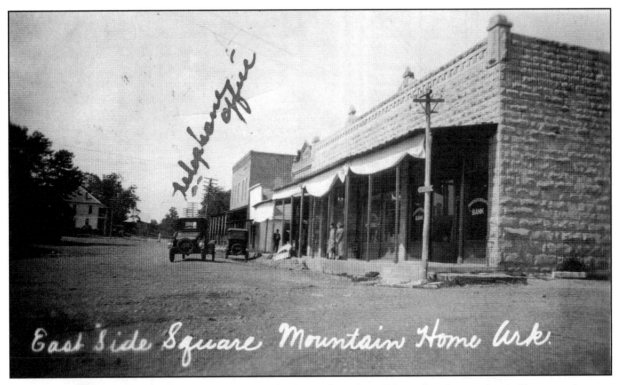

East Side Square Mountain Home Ark.

Mountain Home, 1926 The Baxter County seat's business district formed on all four sides of its courthouse. The unpaved east side of the square (shown here) has been marked to point out the telephone office where two Ford Model T's are parked. The town's name is said to have originated with the slaves on the nearby Col. Orin L. Dodd plantation. The block, with its native stone buildings, is very well preserved and occupied with a variety of shops today.

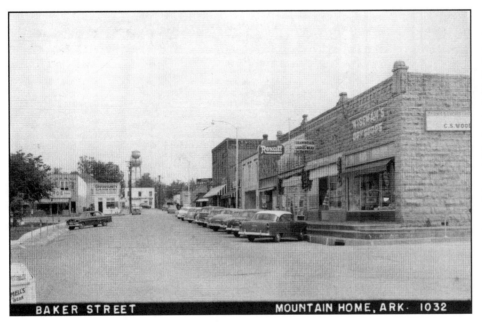

BAKER STREET · MOUNTAIN HOME, ARK. · 1032

Mountain Home, circa 1956 Looking at the east side of the square, the most significant change to Baker Street from the 1920s to the mid-1950s is the street itself. It has been paved. A corner bank had been converted into Wiseman's Dry Goods and Trammell's Ladies Wear, indicative of the family-owned businesses that occupied small-town main streets before the arrival of chain stores.

47

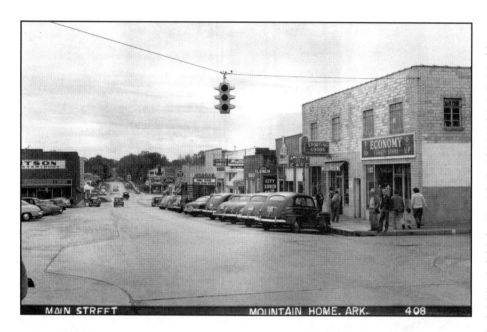

MAIN STREET MOUNTAIN HOME. ARK. 408

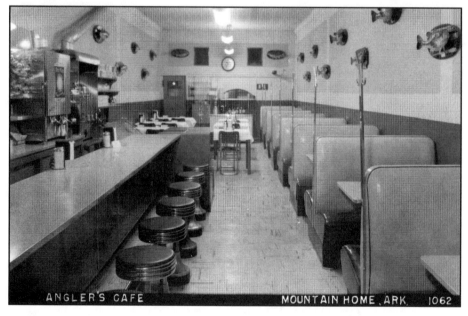

ANGLER'S CAFE MOUNTAIN HOME, ARK. 1062

Mountain Home, 1954
The completion of the Norfork and Bull Shoals dams on the White River transformed once-sleepy Mountain Home into a fishing paradise. President Harry Truman had dedicated both dams in 1952. In the center of Main Street, just down from the Economy Variety Store and D&D's Sporting Goods, is the Angler's Café (bottom photo), whose owner decorated the interior with trophy fish from area lakes and the White River. Today, Baxter County lakes and the White River continue to satisfy trout-fishing enthusiasts. Farther down the block, the Morgan theater was showing *Tarzan's Desert Mystery,* in which actor Johnny Weissmuller as Tarzan was seeking a malaria serum extractable from jungle plants to use in fighting both Nazis and prehistoric monsters. This block is mostly gone today, replaced by a parking lot beside busy Highway 62.

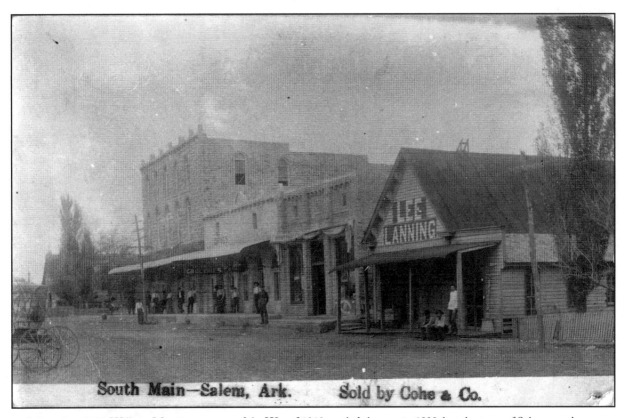

South Main—Salem, Ark.　　　Sold by Cohe & Co.

Salem, circa 1910 William Morris, a veteran of the War of 1812, settled the area in 1839, but the town of Salem wasn't incorporated until 1900. The town's name may have come from the Bible or from a popular town dog; local legends offer both theories. The stone buildings on South Main facing the courthouse survived. Lee Lanning's frame building didn't.

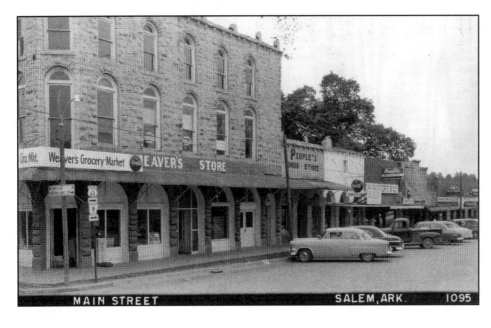

MAIN STREET　　　　　　SALEM, ARK.　1095

Salem, 1956 By the 1950s, as indicated by the signs on the corner, Highways 62 and 9 passed through the square where Weaver's Grocery Market stood beside a drug store and a café. The three-story building that housed Weaver's had apparently been a bank and hotel at different times. Today, a New Orleans–style second-floor balcony has been added, but the renovated building is largely vacant.

49

Mammoth Spring, circa 1915
The massive spring on the edge of Mammoth Spring gave rise to both the Spring River and a state park, as well as giving the town its name. A century ago, Main Street was crowded with horse-drawn wagons, bicycles, and the occasional automobile. Traffic packed down the dirt street in the Fulton County tourist town. Most of the buildings have been restored in what is still a vibrant Ozarks foothill town frequented by tourists and river-sport enthusiasts.

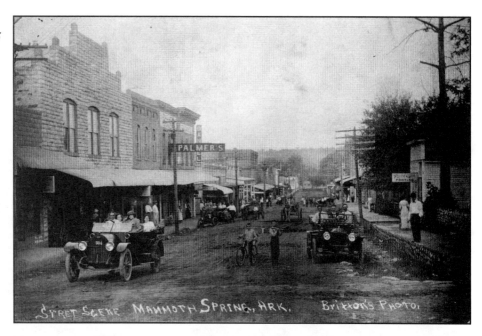

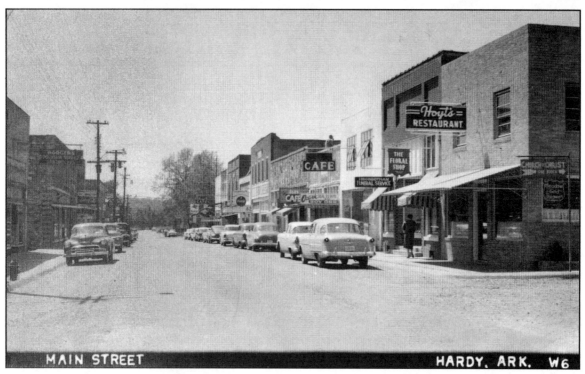

Hardy, 1959 Though residents tried to name the town Forty Islands after a nearby creek, the postal service prevailed by naming the Sharp County town after railroad man James Hardy. By the 1950s, its Main Street shared a path with Highway 62; its businesses included Hoyt's Restaurant and Ira's Café, with Higginbotham's Funeral Service and a floral shop rather oddly sandwiched in between the eateries.

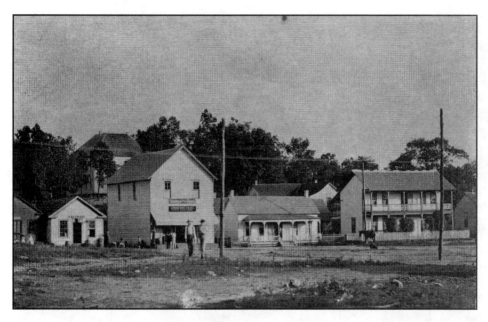

Ravenden Springs, 1907
The postcard's message to an Illinois recipient reads, "We expect to leave Ravenden Springs and turn our noses homeward Saturday morning. Mrs. D and I are feeling fine." According to local folklore, a cave on nearby Hall's Creek where ravens were said to roost gave the town its unique name. The 1907 wood-frame business district of the Randolph County town is gone today.

Pocahontas, 1914 The Randolph County seat, located on the Black River, was platted in 1836, the year of Arkansas's statehood. Its business center was on the courthouse square, the section shown here containing at least two saloons doing business on a busy Saturday. Most of the historic buildings still stand today on a square that holds a marvelously restored 1872 courthouse building.

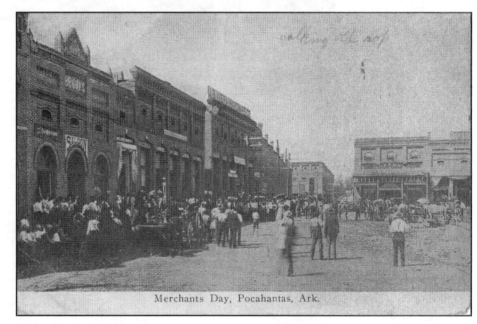

Merchants Day, Pocahontas, Ark.

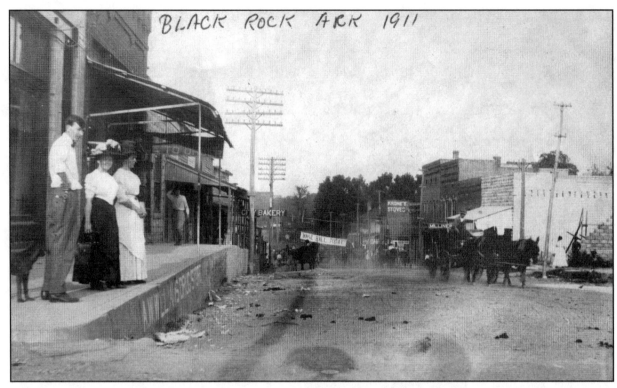

Black Rock, 1911 This Lawrence County town was named for unusual black rocks found in the area. The small town's Main Street displayed a banner proclaiming "BASE BALL TODAY" as horse-drawn wagons made their way up the street. Present on the street were such businesses as the City Bakery, a millinery (a store specializing in hats and clothes for women), and a hardware store advertising Krone's Stoves. Most of the buildings still stand today, though many are vacant.

Hoxie, 1913 The Main Street of the Lawrence County town named for Missouri Pacific Railroad official H. M. Hoxie was struck a powerful blow on a March day when a tornado, then called a cyclone, wiped out a major portion of the business district. Then, as now, people were drawn to the aftermath of nature's fury, and enterprising photographers put such images on postcards that would be sold in local drug stores.

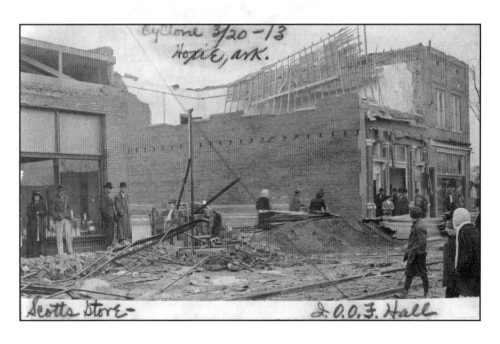

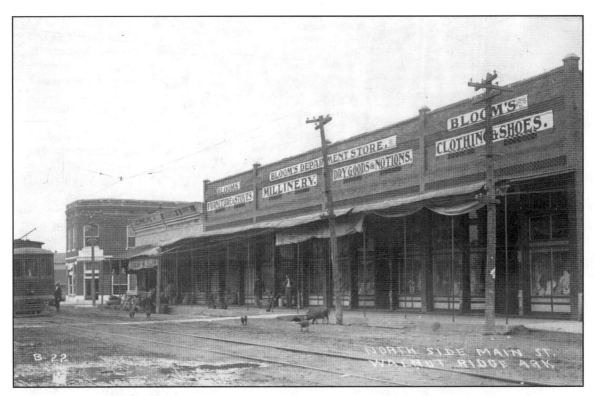

Walnut Ridge, circa 1910 Founded in 1873 as the railroad was laying tracks, Walnut Ridge took half its name from stately walnut trees of the area and the other half of its name from a nearby ridge. Bloom's Department Store took up most of a block of Main Street, offering shoppers in the Lawrence County seat a wide variety of merchandise. Hogs walked in the dirt street at the time, as the interurban trolley car approached from the left. The trolley connected Walnut Ridge with its adjacent community of Hoxie. The Bloom's building is gone today.

Walnut Ridge, 1958
By the 1950s, Main Street, having long been paved, was a part of U.S. Highway 67, which brought thousands of motorists through the business district. A portion of the Bloom's store building shown above in 1910 still stood a few doors down from Sexton's Drugs but is gone today, having been replaced by the First National Bank of Walnut Ridge building.

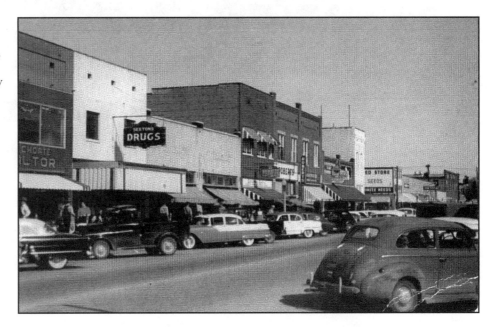

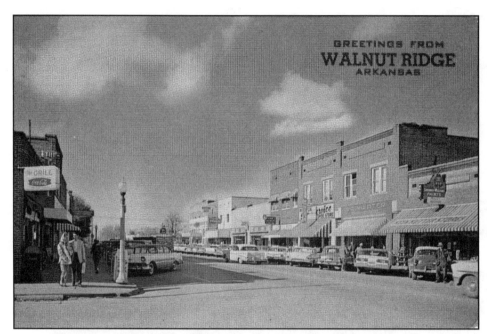

Walnut Ridge, circa 1957 and 1945 Highway 67 brought an increasing amount of traffic onto Main Street, benefiting merchants and filling the seats at the Grill on the left-hand corner (top photo). In the photo below, the Grill is seen from the front, its neon signs advertising K.C. Steaks and Fried Chicken. Today, the building serves as a church.

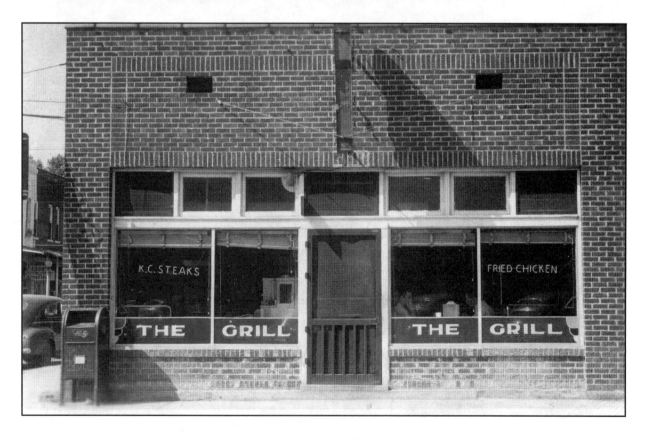

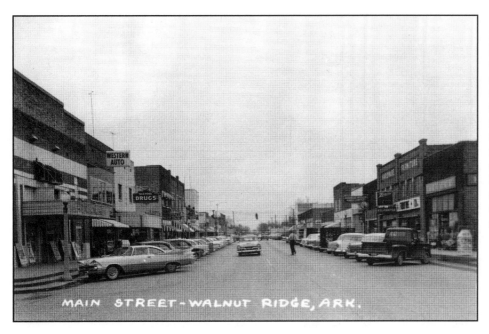

MAIN STREET-WALNUT RIDGE, ARK.

Walnut Ridge, circa 1956
Motorists coming from the north on U.S. Highway 67 would have turned the corner onto Main Street with the movie theater on the left, next to Western Auto. The theater is shuttered today, and Western Auto is gone. Most of the buildings still stand, while much of the retail commerce has moved out to the edge of town.

Imboden, circa 1910
Benjamin Imboden migrated to what was then the Arkansas Territory in 1828, and his name was chosen for the town that sprang up (ca. 1887) with the coming of the railroad. Main Street sloped downhill toward the Black River past Sloan's mercantile and other shops. Before air conditioning became common, most glass storefronts were outfitted with awnings as shields from the sun. Virtually all the buildings are gone today.

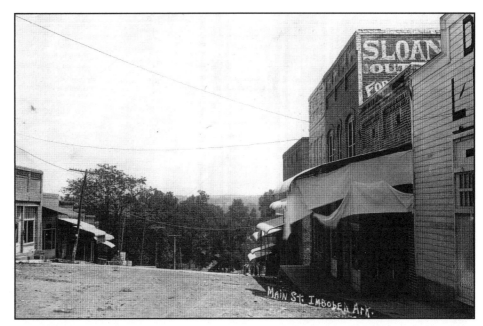

MAIN St. IMBODEN ARK.

55

Corning, circa 1912
One of two Clay County seats—sharing the honor with Piggott—Corning was incorporated in 1877 and named for a railroad official. One store promoted a "Spring Opening Sale," and the business on the right advertised "Restaurant and Board." The card below was mailed to Pennsylvania with a message "This place is as bad as Norfolk for skeeters." Visitors might have stayed at the St. James Hotel (right) and dined at the restaurant at the end of the block (near the parked wagon).

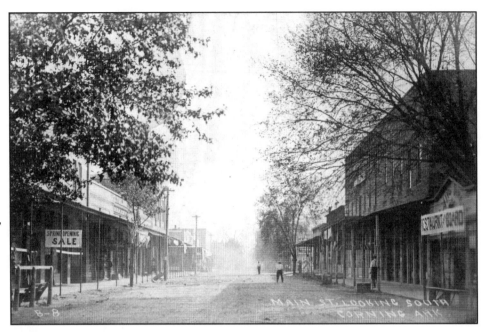

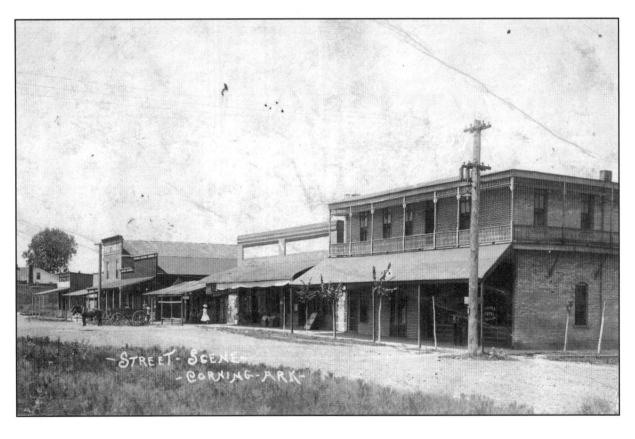

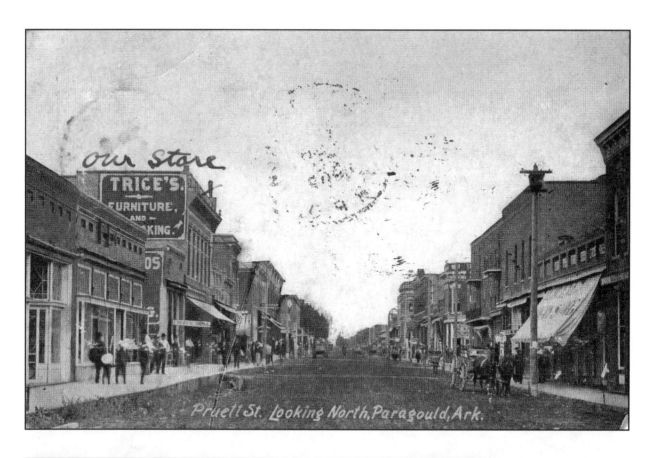

our store

TRICE'S
FURNITURE
AND
...KING

...DS

Pruett St. Looking North, Paragould, Ark.

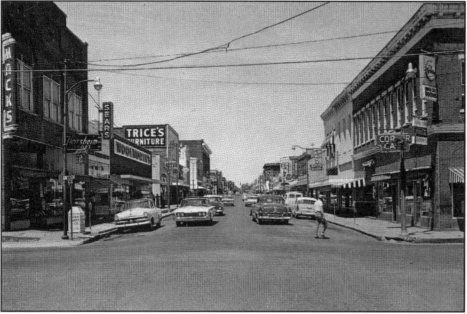

Paragould, 1909 and circa 1960 For decades, the main business artery of the Green County seat was Pruett Street, unpaved in the 1909 view above. Its most prominent merchant was H. S. Trice, who operated a combined furniture and undertaking establishment to the left (where a family member marked "our store"). Fifty years later (below), the Trice family had given up undertaking but still sold furniture. Today, most retail business is on the edge of town; Trice's store closed after almost 60 years of service.

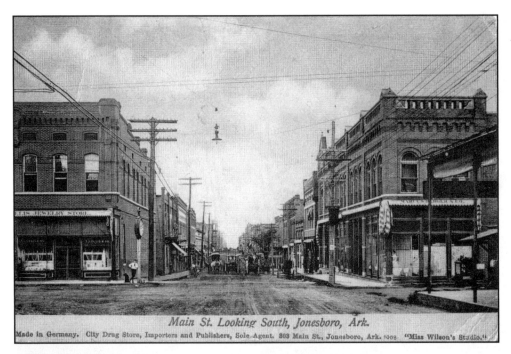

Main St. Looking South, Jonesboro, Ark.

Made in Germany. City Drug Store, Importers and Publishers, Sole Agent. 303 Main St., Jonesboro, Ark. 1008 "Miss Wilson's Studio."

Jonesboro, 1907 and circa 1940 Main Street's intersection with Washington was a cornerstone of commerce for at least 50 years. By the time of the later photo (below), Jonesboro's population was 12,000. Purvis Jewelers was a mainstay on Main Street in the 1950s.

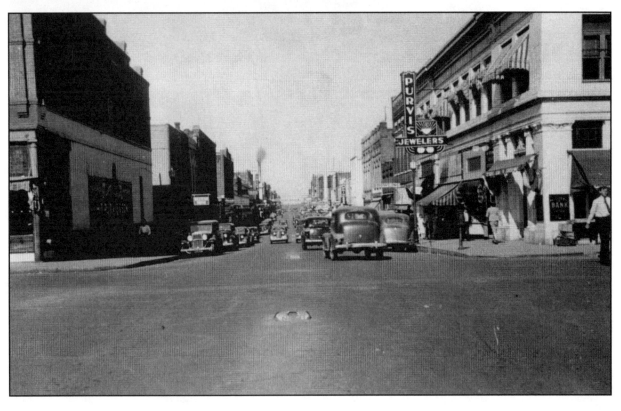

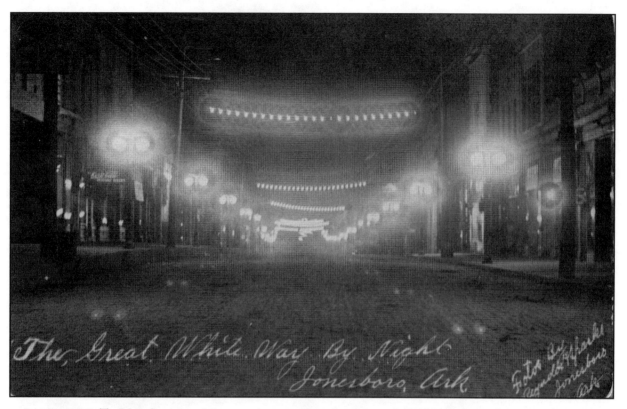

The Great White Way By Night, Jonesboro, Ark.

Jonesboro, 1912 The Main Street merchants stayed open on Saturday nights and complained about safety after dark. The city responded with electric lights along the still-dirt street. Labeled on the postcard as "the great white way," the electrified Main Street was a point of great pride to the Craighead County seat.

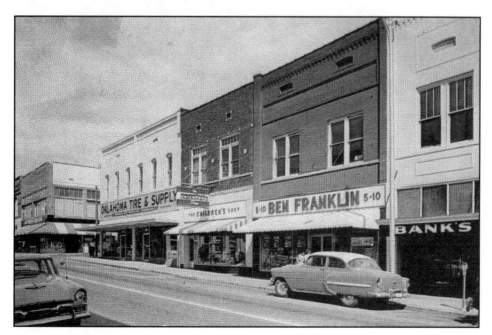

Jonesboro, circa 1955 From left to right on Main Street were aligned retailers that once staked a claim on almost every Main Street of an Arkansas town of any size. Sterling, Oklahoma Tire & Supply (OTASCO), and Ben Franklin 5-10 stores have faded into the retail history books.

Blytheville, 1907 and 2009
The Mississippi County town, founded and named for Methodist clergyman Henry Blythe in 1879, prospered first from timber and then from farming. In this century-old view (top photo) looking east down the dirt Main Street, a visitor from New York penned, "From Arkansas, land of cotton, swamps, mules and negroas." The writer had stayed at the Hotel Crenshaw just beyond the train tracks (tracks that can be seen in this view behind the mule-drawn wagon). A century later, the hotel is gone but most of the buildings on the right side of the street are restored. Thanks to an enthusiastic core of local preservationists, occupancy is high on this block.

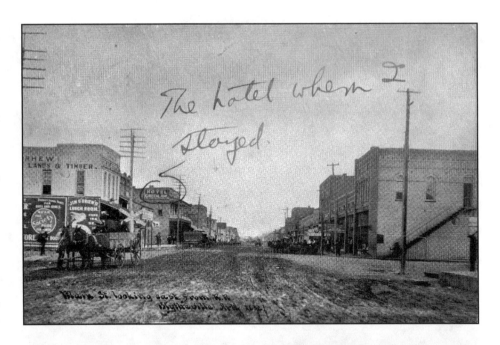

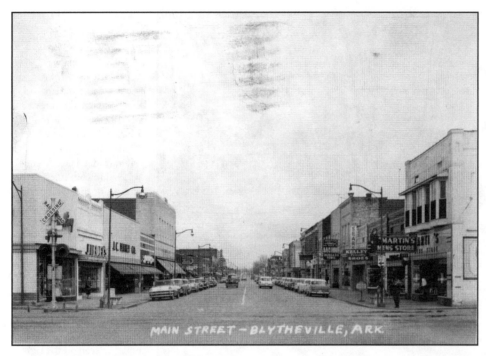

MAIN STREET – BLYTHEVILLE, ARK.

Blytheville, circa 1960 The view closely matches that seen on the previous page in an era before the shopping centers took away retailers such as J.C. Penney (on the left) and Sears (on the right side of the street in this view).

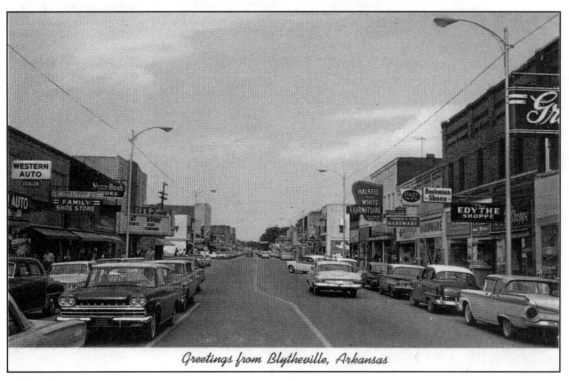

Greetings from Blytheville, Arkansas

Blytheville, circa 1957 Many large cars sported tail fins as the drivers vied for rare parking spaces on a street lined with locally owned stores. The stores included Western Auto, Halsell & White furniture, a hardware store, and at least three shoe stores. The Ritz was showing Pat Boone in *State Fair* (left). Today, the Ritz has been restored as a performing arts center.

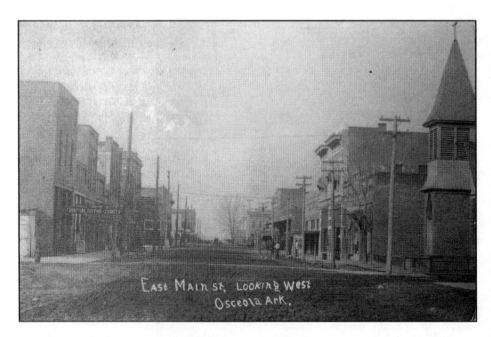

East Main St, Looking West
Osceola Ark.

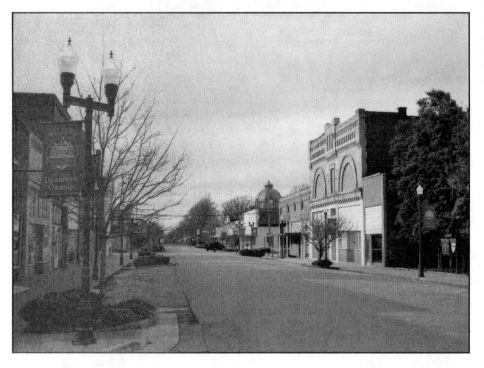

Osceola, circa 1910 and 2009 Incorporated in 1853, Osceola was apparently named for the Seminole Indian chief who tried to prevent his tribe's removal from Florida. By the early twentieth century, East Main (today Hale Avenue) was muddy but lined with enterprise, including the shop to the left advertising "FURNITURE, COFFINS AND CASKETS." Coffins were apparently built in the shop by a carpenter, while the more expensive caskets were ordered from a distant factory. In 1910, Osceola's population stood at 1,769. The Bank of Osceola's 1909 building seen on the right dominated the street. The Episcopal Church faced the street as well. The historic street is largely intact as of 2009, while the copper dome of the Mississippi County Courthouse, built in 1912, is visible in the distance. The church now faces away from Hale Avenue.

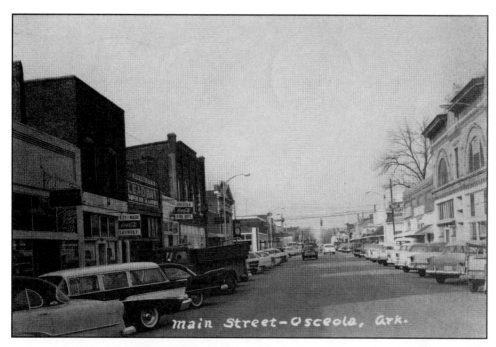

Main Street—Osceola, Ark.

Osceola, 1958 Hale Avenue, paved years before, was lined with small, family-owned retail and service shops. Among the businesses were the EZ Wash Laundry and Leadway's Value Store.

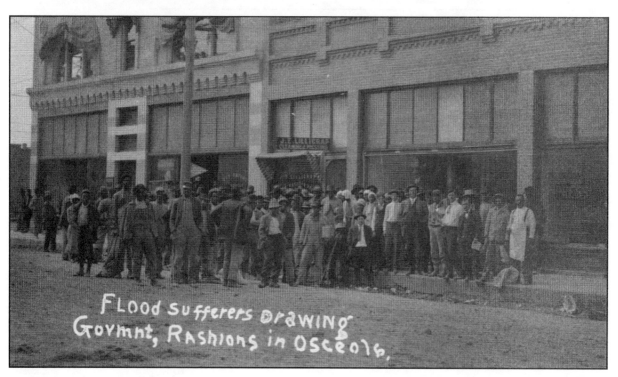

Flood Sufferers Drawing Govmnt. Rashions in Osceola.

Osceola, 1927 The Mississippi River, so vital to Osceola's economy, has also, at times, wrought devastation. Hundreds of area residents lost their homes and personal effects in the record flood of 1927. Many refugees gathered in front of the Bank of Osceola to the left and the R. C. Rose building to the right. Today, the bank building houses drainage district offices, while the Rose building is gone.

Osceola, 1931 During the Great Depression, East Hale Avenue was fronted by small enterprises like G. F. Bryant, The Leader (on the left), and J. C. Brickey's drug store and soda fountain (to the right).

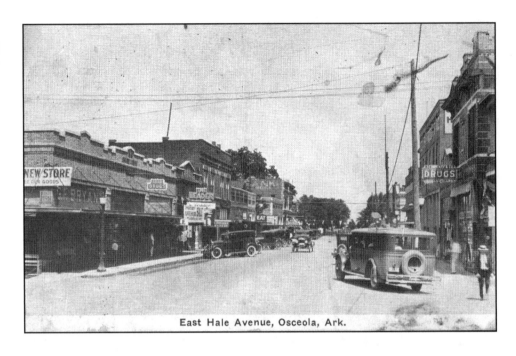

East Hale Avenue, Osceola, Ark.

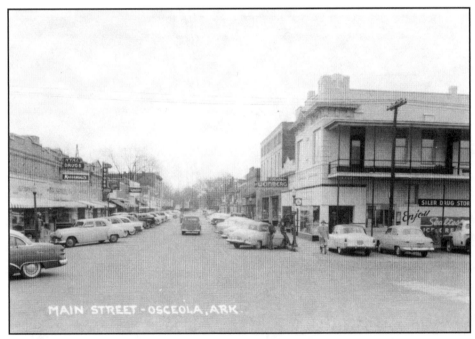

MAIN STREET - OSCEOLA, ARK.

Osceola, circa 1955
Some 25 years after the photo above was taken, Brickey's had become Siler Drug Store advertising Sealtest Ice Cream. Siler's competed with Nyal's Drugs across the street, common in the era before the rise of chain pharmacies. The building that housed first Brickey's and then Siler's no longer stands.

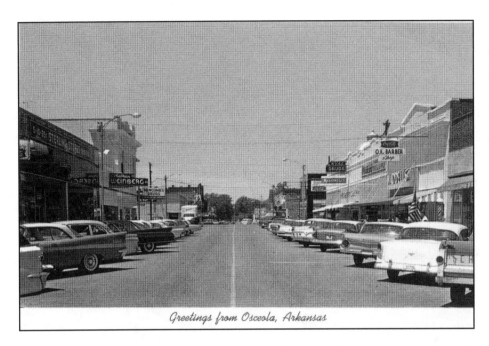

Greetings from Osceola, Arkansas

Osceola, circa 1957
This view of East Hale looks west. The building that last housed Siler's drugs on the left housed Newcomb's Drug by 1957. Sterling operated (left) with OTASCO across the street, adjacent to O.K. Barber Shop. While much of the retail has left downtown, Osceola has labored to maintain its historic street. Several buildings are now listed on the National Register of Historic Places. An impressive walking tour guide is available for visitors.

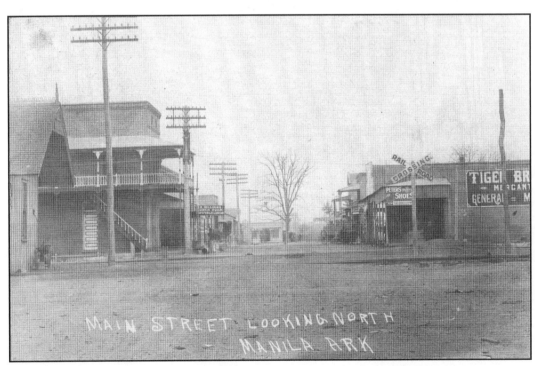

MAIN STREET LOOKING NORTH MANILA ARK

Manila, 1909 Originally founded as Cinda (after Lucinda, the postmaster's daughter), the town's name was changed during incorporation in 1901 to honor Commodore George Dewey's accomplishments in the Philippines during the Spanish-American War. The railroad (see tracks in the foreground) helped make the Mississippi County town a booming lumber center.

Tyronza, circa 1957 In 1883, the Kansas City, Fort Scott and Gulf Railroad built a depot known as Tyronza Station, named after the nearby Tyronza River. By the time of this photo, agriculture had surpassed timber as the major focus of the region's economy. Note owner Joe Hong standing in front of his grocery store.

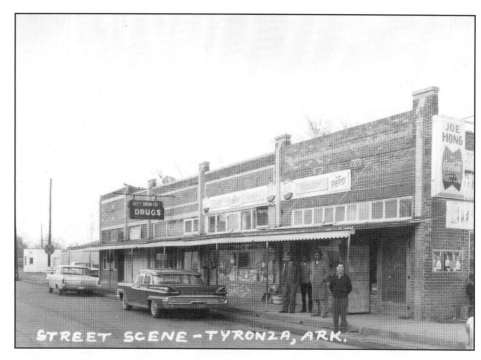

Lepanto, 1936 Named after the Greek seaport of Lepanto, the Poinsett County city is the only municipality in the United States to bear that name. The first settlers arrived in the 1870s. By the time it was officially incorporated in 1909, the town was surrounded by cotton fields. Note the mule-drawn cotton wagons. Today, most of these buildings remain intact. The two-story brick structure on the left was a bank. It is now home to the Museum Lepanto USA, which showcases the area's colorful history. The name was chosen because many items shipped to the town during its early years were addressed simply, "Lepanto USA."

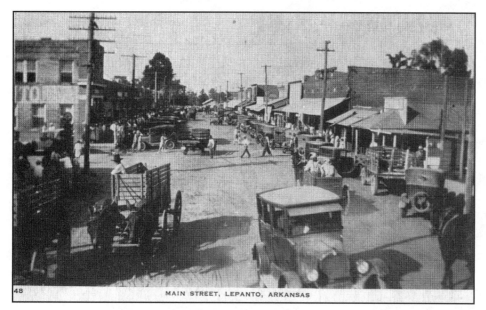

MAIN STREET, LEPANTO, ARKANSAS

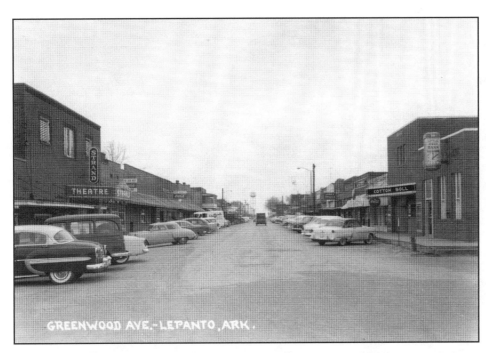

GREENWOOD AVE.-LEPANTO, ARK.

Lepanto, circa 1959 and 2009 The community boasted two movie theaters: the Strand and the Cotton Boll. Today (below), the Stand's marquee is gone and the building is vacant. The Cotton Boll is now part of the Little River Bank, and the nearest theater is in Jonesboro, 35 miles away.

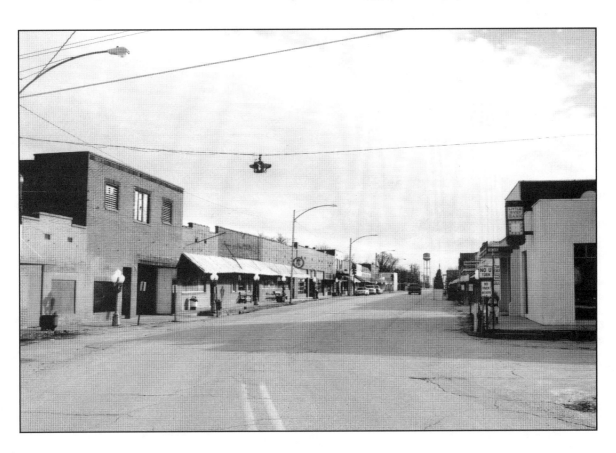

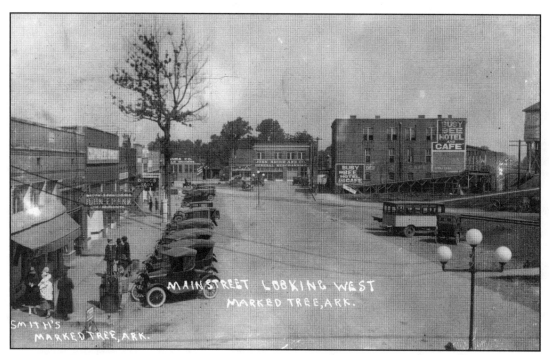

Marked Tree, 1930 Legend has it that notorious outlaw John Murrell blazed an oak tree at the confluence of the St. Francis and Little rivers to mark a good fording place. The community so-branded was incorporated in 1897. It began as a railroad camp. The message on this postcard mailed to Lincoln, Nebraska, reads, "Dear Mrs. Kent, This picture is about 8 years old but the old town hasn't changed much since that time. If you ever visit this country, please look me up. It is a grand place. There isn't much timber work going on here at present. That kind of labor is almost a thing of the past here." In recent years, Main Street has struggled; the Busy Bee Hotel and Café at the end of the street no longer stands.

Marked Tree, circa 1930
The postcard's message reads, "Out riding 40 miles from Memphis. Saw cotton plantations galore and mules and negroes and more. Mother." Note the Budweiser sign. It had apparently been there for years, as Prohibition had been the law of the land for almost a decade. The three-story brick structure on the left with the drug store and Craft Bros. Painters ads on its side is long gone. The same fate has befallen the Masonic Hall at the far end of the square. Most of the other buildings remain intact.

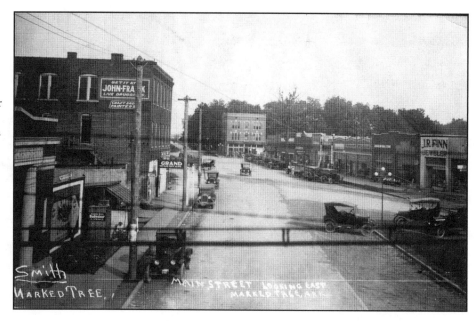

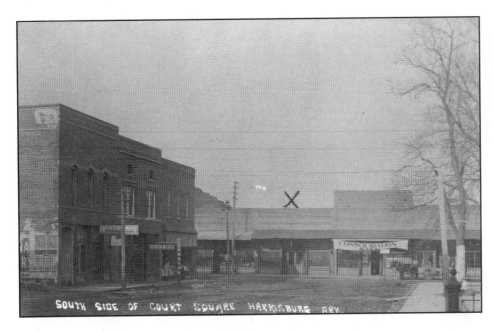

SOUTH SIDE OF COURT SQUARE HARRISBURG ARK.

Harrisburg, 1912 and 2009 The business district of the Poinsett County seat formed along all four sides of a handsome courthouse square. Today, the courthouse still serves the county, but as seen in these almost century-separated photos, the other buildings have not fared as well. The "X" marked on the 1912 photo reads "this is the building where I work"; it now stands vacant.

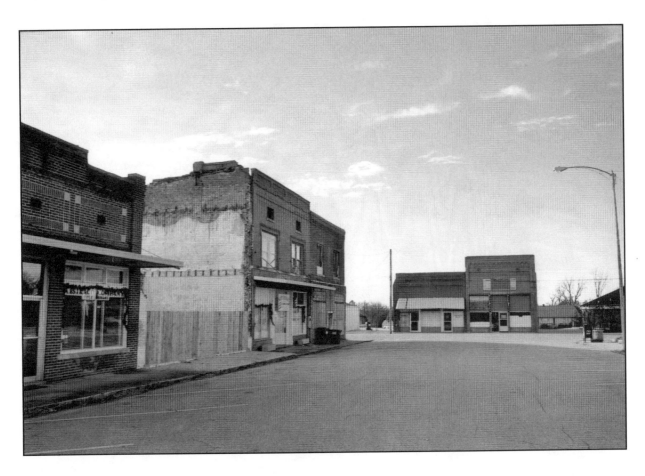

Harrisburg, 1915 The automobile was crowding out the livery stable. Daw's Garage had put up a large, pointing sign on Main Street to draw motorists. Next to this building, a vacant lot behind the fence had been converted to the Airdome Theater hosting plays and other traveling shows. Most of these buildings are gone today.

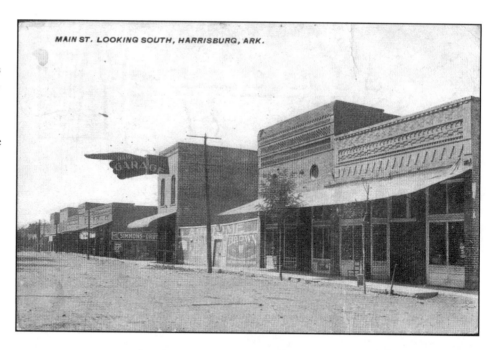

MAIN ST. LOOKING SOUTH, HARRISBURG, ARK.

Weiner, 1912 The snowy Main Street of the Poinsett County town was captured by the camera, including the Weiner Land Company to the left and the two-story Odd Fellows building next door. The card's message tells more, "Am sending you a picture of the part of Weiner that was destroyed by fire a few days before I arrived."

SOUTHEAST ARKANSAS

Southeastern Arkansas, among the most historic regions in the state, stretches from the pine forests of a former ocean's alluvial plain to the rich crop land where a great primeval forest once stood. The area boasts the first European settlement at Arkansas Post, sites of Civil War battles, and Stuttgart—the rice and duck capital of the world. The region faced economic challenges during the twentieth century as mechanization revolutionized agriculture and manufacturing jobs moved overseas. These factors have challenged community efforts to preserve their once-prosperous downtowns, but preservation successes dot the region.

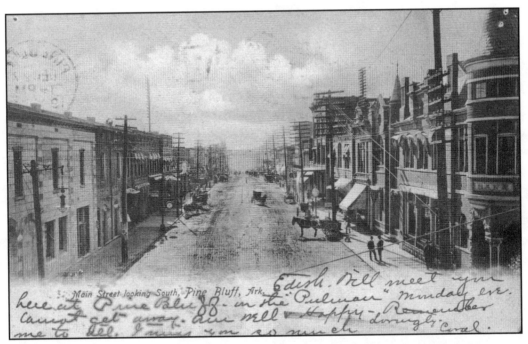

Pine Bluff, 1906 The commercial center of southeast Arkansas has for decades been Pine Bluff. In this scene, a photographer stood on the Jefferson County Courthouse steps a century ago, looking up a then-dirt Main Street rutted with wagon tracks. A number of the buildings to the right still stand. On the east side of the street (left), development such as the Simmons First National Bank tower has replaced older buildings.

Pine Bluff, 1905 and 2009
All the automobile owners in Jefferson County were persuaded to pose in front of the Jefferson County Courthouse (on the right) and the Merchants & Planters Bank (left). In 2009, both buildings stand proudly restored on a once-vibrant street that has struggled in recent years to remain a draw for people.

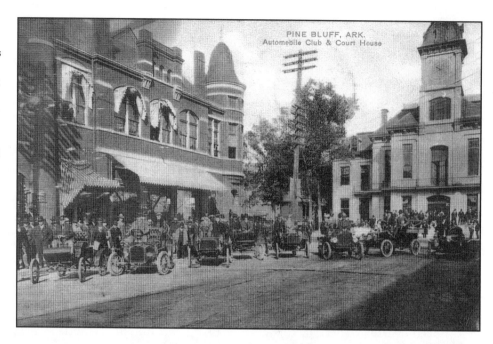

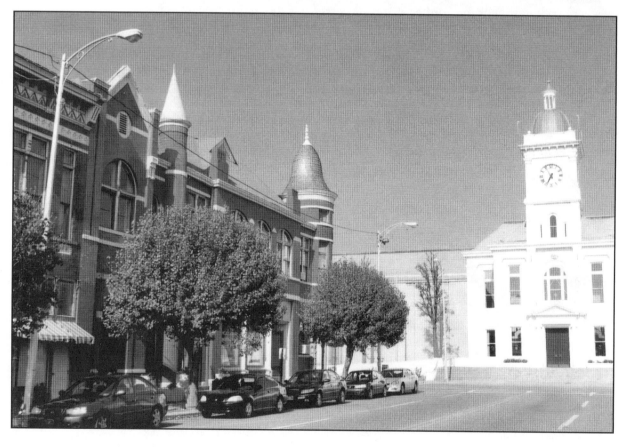

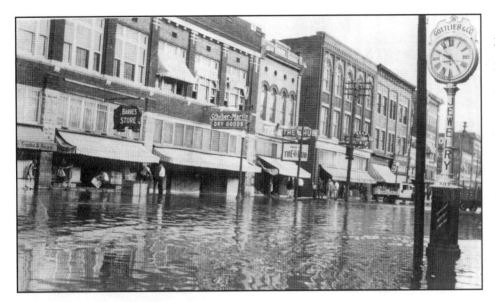

Pine Bluff, 1927 and 2009
The record flood of 1927 pushed the waters of the Arkansas River far up Main Street, reaching into the heart of the shopping district. Flood water halted rail traffic in and out of the Jefferson County seat for weeks. As of 2009, with only the ground floors occupied, the buildings have survived both the flood and the ravages of time.

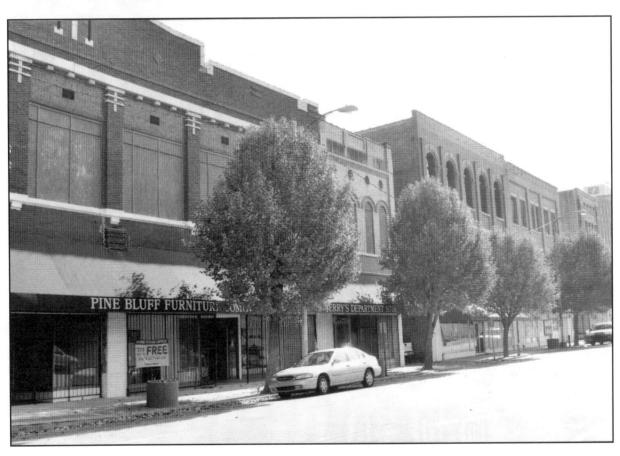

Pine Bluff, circa 1910 and circa 1955 The intersection of 4ᵗʰ & Main is seen in markedly different eras but with common features. The buildings on the right survived, while a modern Kress store occupied the left corner where the railroad tracks crossed. In 2009, the buildings remain much as in 1955, though a number are empty.

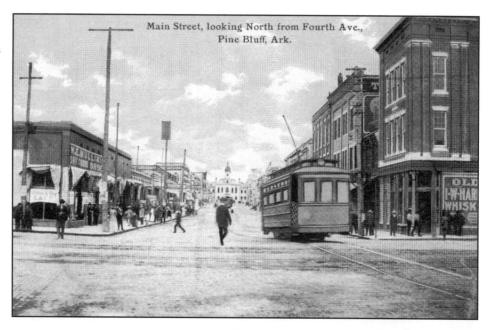

Main Street, looking North from Fourth Ave., Pine Bluff, Ark.

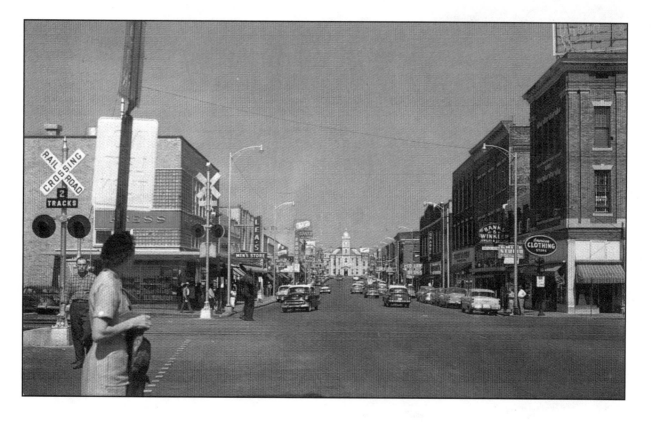

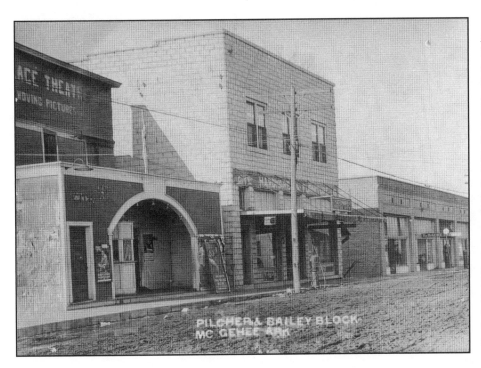

McGehee, circa 1910
Farmer Benjamin McGehee and his family migrated from Alabama to southeast Arkansas in 1857. The Little Rock, Mississippi River and Texas Railroad came to the town in 1878. With greater access to distant markets, agriculture—especially cotton—thrived and the community grew. Note the hardware store, furniture store, and movie theater. In the era before the coming of "talkies," most small-town movie houses had a pianist whose music contributed to the atmosphere and provided vital emotional cues for the audience.

McGehee, circa 1910
The Desha County town's main street boasted two saloons. Over the years, the town has often been the victim of fires and floods. The Flood of 1927, which covered all of Desha County with water ranging in depth from four to thirty feet, came in April and remained until early summer. Most of McGehee's population fled. A few holdout-families took refuge in the second floor of the saloon and other commercial buildings. The community did not recover until after the Great Depression. Today none of these structures remain, with the exception of the railroad depot on the left. While cotton continues to be the major crop, rice and soybeans are increasingly important.

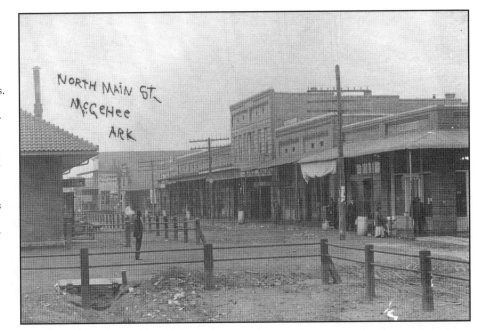

McGehee, 1951 and 2009
After the flood of 1927 destroyed Main Street, the business district moved over a block to First Street, which became the revived business district. In the starkest of contrasts found in researching this book, the 2009 view shows the impact of fires and mankind's rush to tear things down. The only identifiable landmark is the now-shuttered bank on the left corner.

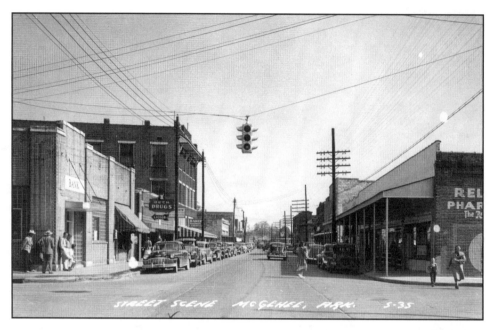

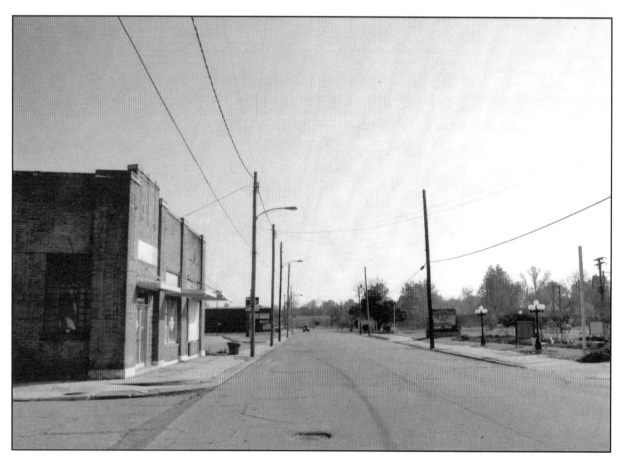

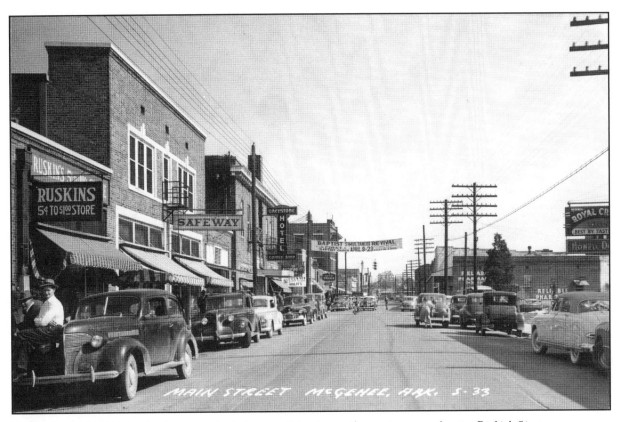

McGehee, 1951 This view is taken a couple blocks west of the view on the previous page, showing Ruskin's 5¢ to $1.00 Store, Safeway, the Greystone Hotel, and a banner over the street announcing a rally by First Baptist Church. The buildings are gone today, all the commerce relocated to nearby Highway 65.

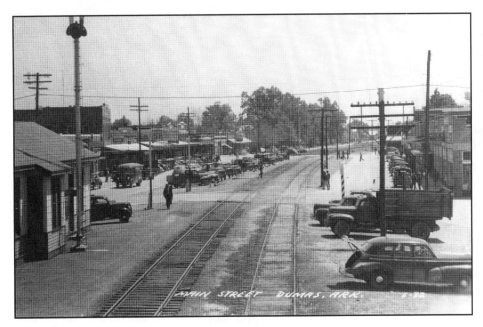

Dumas, circa 1945
Named for early settler W. B. Dumas, who bought the Desha County land for $1.25 acre in 1851, Dumas today is proud of one of the most intact and occupied downtowns in southeast Arkansas. Railroad tracks still dominate the center of town, offering a view not so unlike this one of decades ago.

Lake Village, circa 1945 and 2009 Although still struggling to compete with Wal-Mart outside of town on Highway 65, the Main Street of the Chicot County seat remains among the most intact in southeast Arkansas. Though these photos are six decades apart, the stately Bank of Lake Village's only outward concession to modernity is a digital temperature sign.

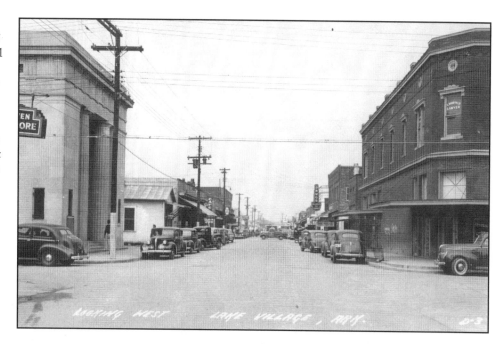

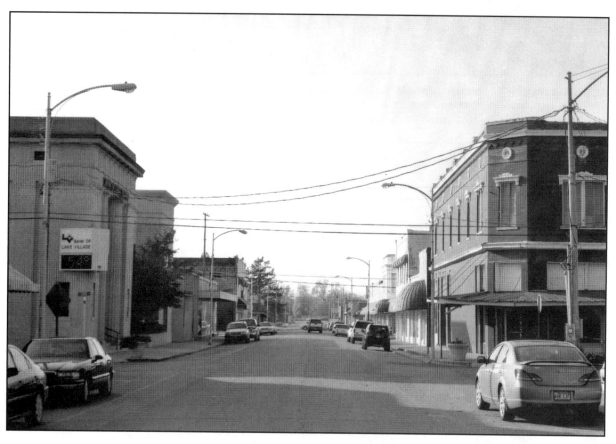

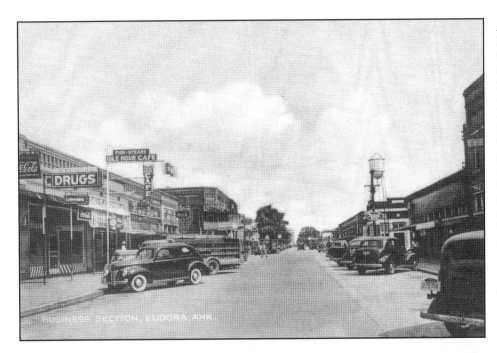

Eudora, circa 1945
Dr. S. A. Scott founded the town when the railroad arrived early in the twentieth century, naming it for his daughter, Eudora. By the time of this postcard, Main Street was a vibrant mix of retail and dining, such as served up at the Idle Hour Café (seen here advertising "fine steaks"). Today, only some of the buildings survive. The largely empty business district is a result of declining population and the loss of manufacturing jobs. Most traffic today hurries by on Highway 65, a couple of blocks east of Main Street.

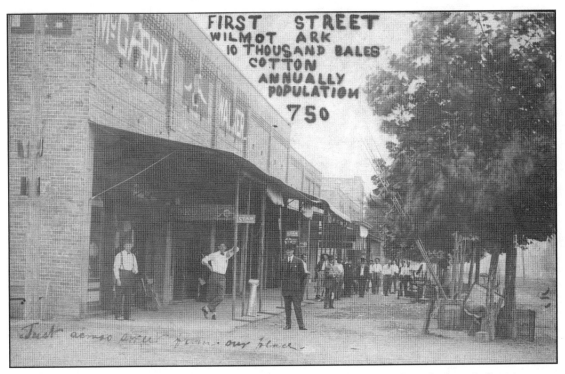

Wilmot, circa 1910 The tiny Ashley County town was born in the pine lumber belt not far from the Louisiana border. The line of trees had been planted to shield the row of stores a bit from the train (note the tracks just to the right). The railroad would have shipped the touted annual 10,000 bales of cotton. Remarkably, the town's population of 750 a century ago is almost exactly the same today, reported to be 786 by Wikipedia.

Monticello, circa 1935
The Drew County seat was incorporated in 1852 and is thought to have been named for the home of President Thomas Jefferson. The small college town's thriving retail district was centered around the courthouse square and included Main Street icon Sterling 5 cent to $1 Store. Though a number of buildings survive downtown, today most of the retail business is near the highway bypass areas.

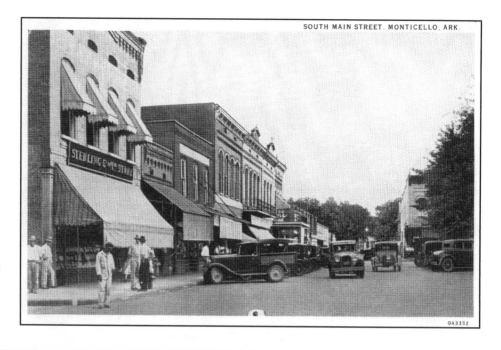

SOUTH MAIN STREET. MONTICELLO, ARK.

OA3352

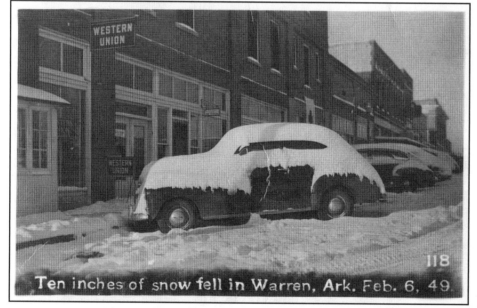

Ten inches of snow fell in Warren, Ark. Feb. 6, 49.

Warren, 1949 War of 1812 veteran Capt. Hugh Bradley bestowed his name on Bradley County. According to Ernie Deane in *Arkansas Place Names,* it was his slave, Warren, whose name was given to the county seat. In this 1949 scene, the only town in Arkansas named for a slave found its Main Street covered by a rare snowfall, Western Union offices, once a common sight, are hard to find today in the age of e-mail.

80

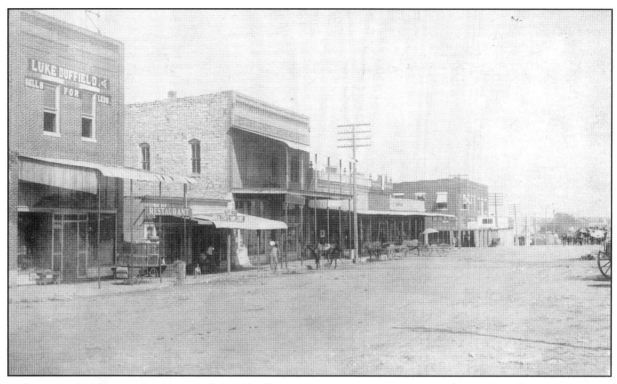

Stuttgart, 1911 The grand prairie town founded by German Lutheran immigrants was already prospering from rice production almost a century ago when its wide, dirt Main Street included such businesses as Luke Duffield's General Store and Okley's Real Estate and Farm Loans.

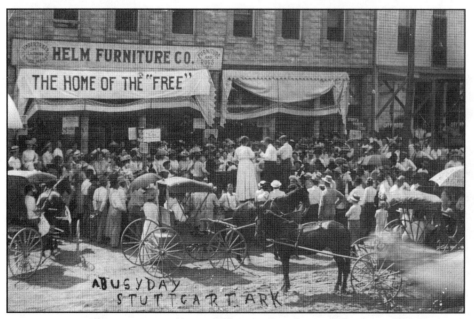

Stuttgart, 1911
Helm Furniture Co. in the Arkansas County seat was giving away "free" sewing machines, a crowd-pleasing promotion staged in conjunction with the Singer Sewing Machine Co. Note that the establishment also offered licensed undertaking and embalming services. Combining burial preparation with the home furnishing business was a common practice in that era. The message on the postcard reads, "This will show you we are still doing business in Stuttgart. I was out this morning and killed 35 squirrels."

Stuttgart, 1908 and 1911 The prosperous farming center's Main Street was often visited by families coming in their buggies to shop and socialize. At the time, many of the stores were still in wooden-frame buildings. During the heady 1920s to come, nearly all frame buildings in down-town would be replaced by brick structures.

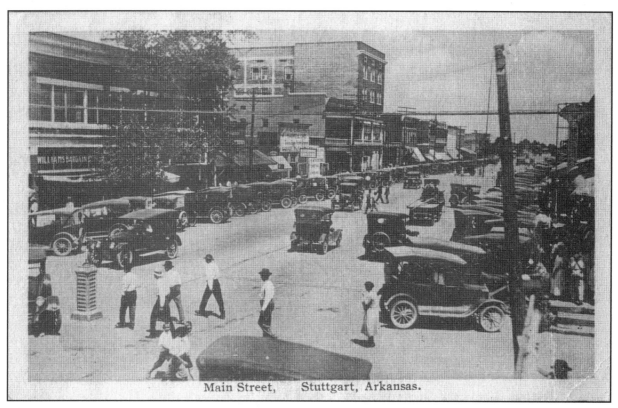

Main Street, Stuttgart, Arkansas.

Stuttgart, circa 1920 The roaring '20s were good to Stuttgart. Many new automobiles jammed Main Street, especially on Saturdays. Virtually all the autos were black Ford Model-T's.

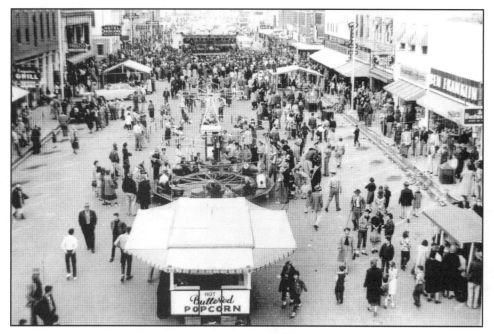

Stuttgart, circa 1955
The annual Rice Carnival closed Main Street to automobiles and opened it to carnival rides and fair food. Ben Franklin and West Brothers Department Store are to the right. *(Photo courtesy of the Museum of the Arkansas Grand Prairie, Stuttgart)*

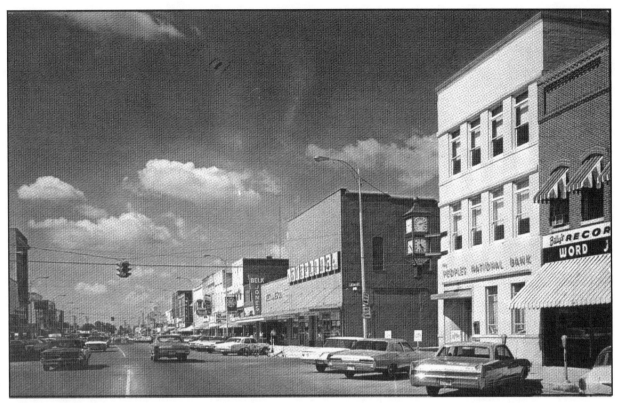

Stuttgart, circa 1975 Main Street was still the heart of the shopping district with such stores as Sterling and Belk. Today, most of the buildings remain, though with different merchants, as the community strives to keep Main Street vibrant.

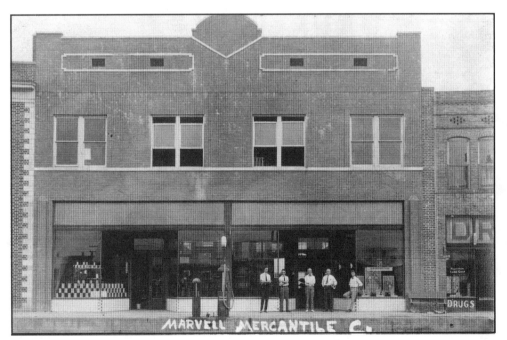

Marvell, circa 1920
The hardware and general merchandise store located on Main Street served the Phillips County farming community, including pumping gas from the gravity-fed tank on the sidewalk in front of the store.

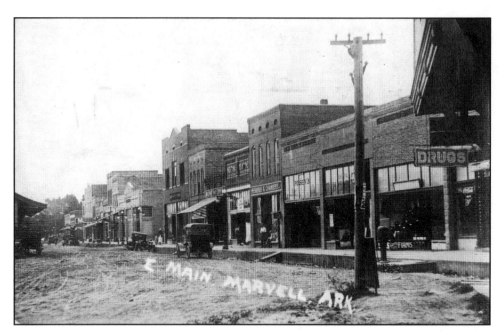

Marvell, circa 1915 and 2000 As the small community prospered from timber and agriculture, its vibrant Main Street benefited. In the twenty-first century, demographic and economic shifts have taken population away. The buildings remain but in poor repair and often empty. The former Marvel Mercantile building still stands in the middle of the block.

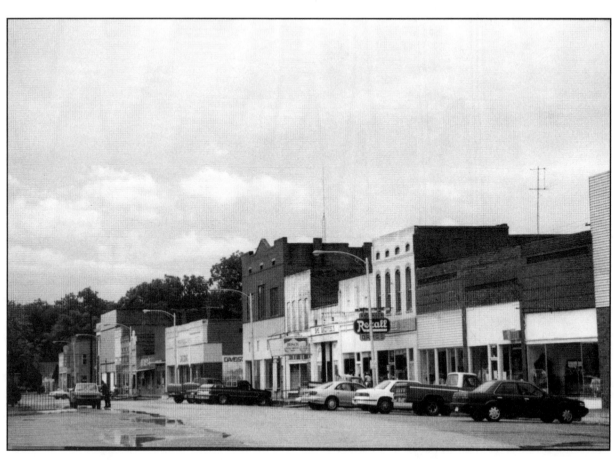

Helena, 1907 Cherry Street was the main street of the once-booming Mississippi River town founded well before the Civil War. The sender of the postcard had "arrived Oct 14th," and would have walked the still-dirt street, stopping to buy this postcard most likely in a pharmacy.

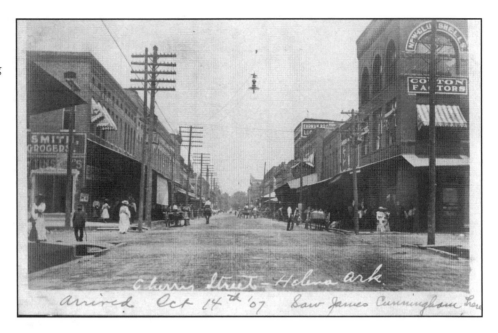

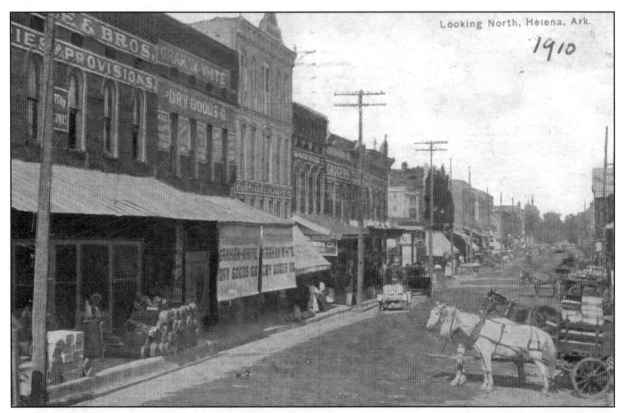

Helena, 1910 "Business very good last week," said the penned message on an image of historic Cherry Street where the Graham-White Dry Goods Co. was having a sale. Note the wagons backed up to receive and deliver (on the right). Most of these buildings still stand, though many are vacant.

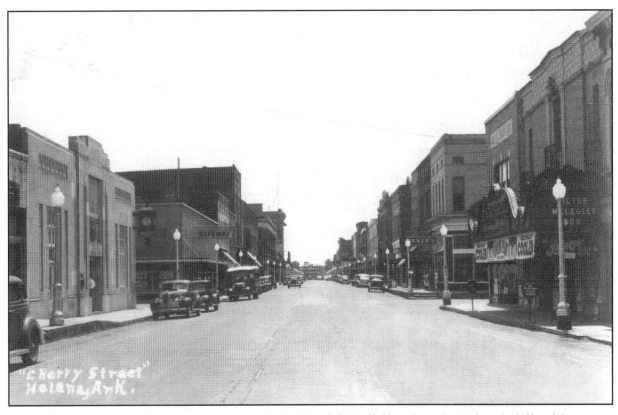

Helena, circa 1945 Cherry Street was home to the chain grocery Safeway (halfway down the block on the left) and the air-conditioned Paramount Theater on the right, which was also promoting bingo games. Downtown supermarkets were the rule during the era before the necessity for large parking lots caused them to move to the edges of towns.

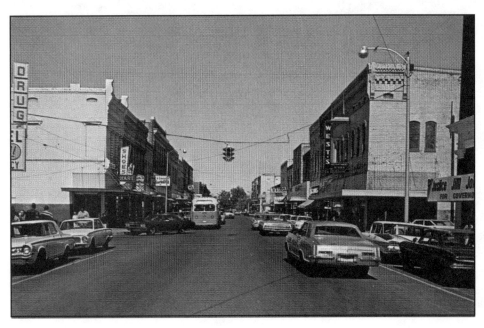

Helena, 1966 Cherry Street was still the place to shop, and even enjoy bus service. Also located in the heart of downtown was the campaign headquarters for "Justice" Jim Johnson, the Democratic nominee for governor. While the historic street retains much potential, it has suffered considerably due to population loss and a shift of the retail sector to an outlying shopping center.

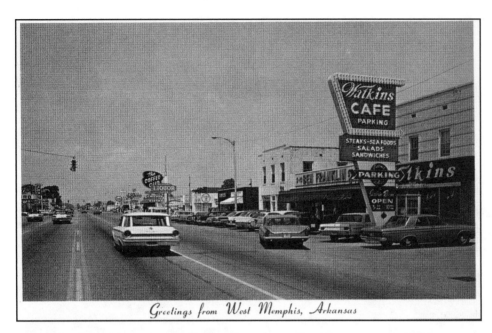

Greetings from West Memphis, Arkansas

West Memphis, circa 1960 and 2009 Crittenden County's largest city lies in the shadow of Memphis, Tennessee, just a few miles to the east. West Memphis shared its Main Street with Highway 70 traffic prior to the creation of I-40. Today, as shoppers frequent big box stores and chain diners, former Main Street mainstays such as Ben Franklin and Watkins Café are gone, as are their classic signs, which once captured the eyes of passing motorists.

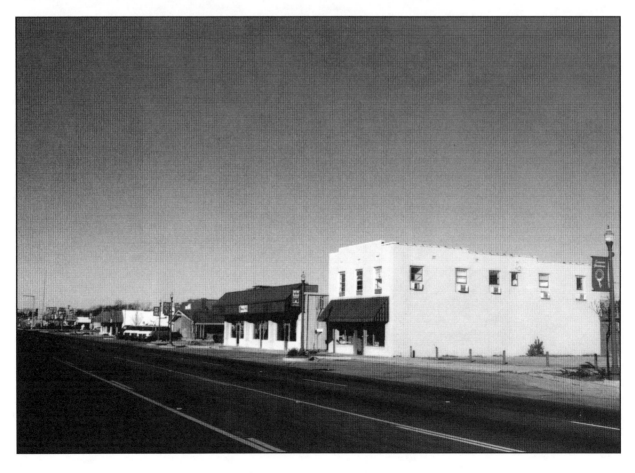

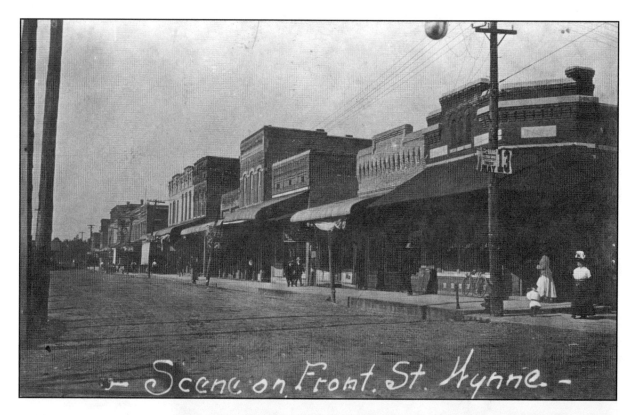

Scene on Front. St. Wynne. -

Wynne, circa 1910 and 2009
In 1882, the St. Louis, Iron Mountain and Southern Railroad was laying track in the area when a train derailed, leaving behind a boxcar. The car was righted and became the impromptu depot for the newly conceived Wynne Station. The town was named for Captain Jesse Wynne of Forrest City, founder of that community's first bank. When Wynne later became the Cross County seat, the first county documents were kept in an opera house on Front Street until a court-house was built in 1915. Note the well-dressed woman coming out of the bank and the bicycle leaning against the building. Today, as seen below, most of these buildings still stand, but many are vacant and in need of restoration.

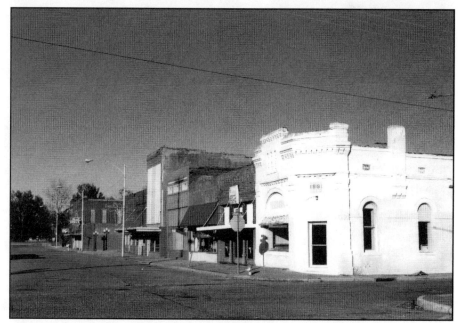

Wynne, 1909 and 2009
The town's business district was composed of Front Street in the foreground, intersecting with Merriman Avenue, down which the photographer's lens was pointed. The 1909 message penned on the photo of the very busy intersection read, "Just heard about poor Wilbur being dead, It's too bad." Today, the intersection is much emptier, with the building that once sat at the right reduced to a concrete slab, the one on the left boarded up.

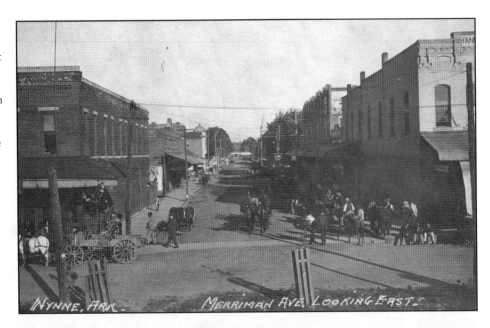

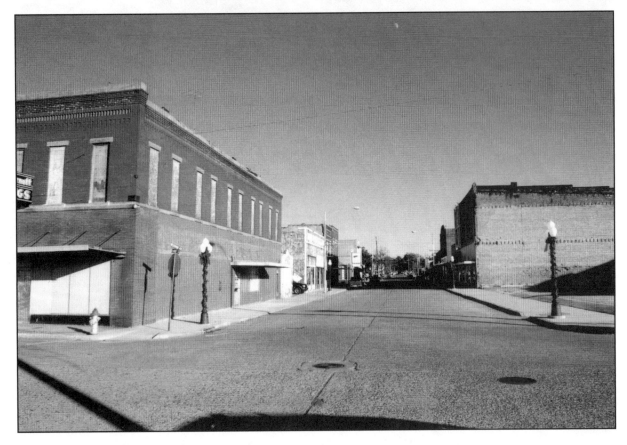

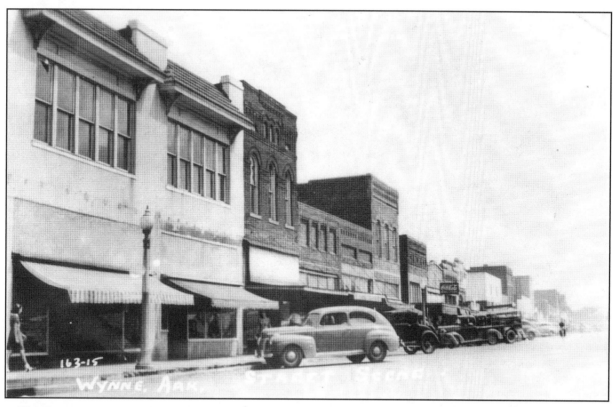

Wynne, circa 1945 and 2009 Most of the Cross County seat's retail businesses lined several blocks of Front Street, which faced railroad tracks. Trains brought both merchandise for the stores and passengers, many of whom would patronize Front Street merchants. As seen today (2009), Wynne has perhaps one of the most-endangered downtowns in the state. Many buildings sit empty and in disrepair.

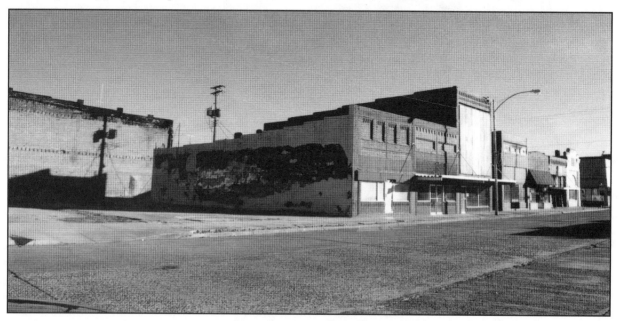

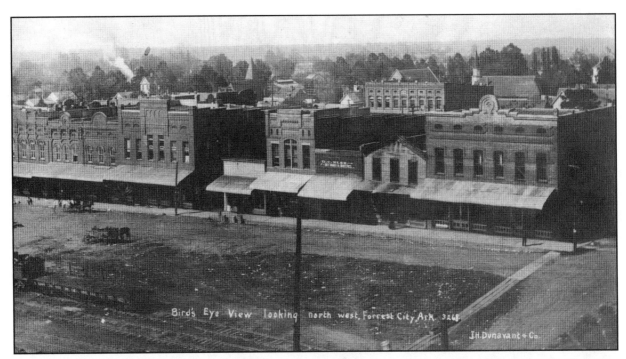

Forrest City, circa 1910 The St. Francis County seat was moved to Forrest City in 1874, named for famed Confederate cavalry general Nathan B. Forrest. The main business street, seen here from atop the county courthouse, was Front Street. Today, some buildings are gone and those that remain are in poor repair. The historic street is one of the state's most endangered.

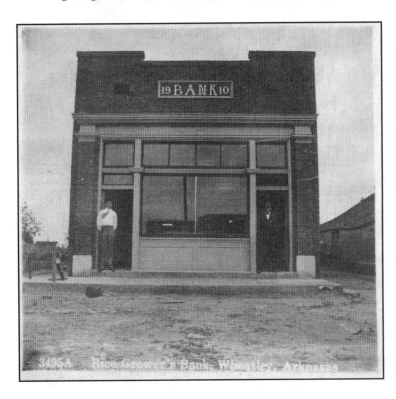

Wheatley, 1910 Today, the tiny St. Francis County town of some 300 is only a freeway exit sign to most travelers on I-40 and is seldom visited. A century ago, Wheatley was on the edge of the booming rice belt, its short Main Street home to the aptly named Rice Grower's Bank, the small building equipped with two front doors.

chapter four

SOUTHWEST ARKANSAS

Southwestern Arkansas, reaching from the Ouachita Mountains through the piney woods and oil patches near the Louisiana state line, offers a rich history wrapped in timber, oil, and wildlife resources. The region offers some of the best examples of Main Street preservation, especially El Dorado, which could serve as models for other parts of Arkansas.

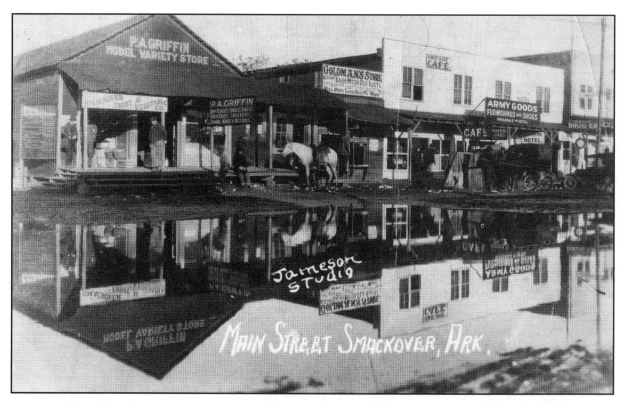

Smackover, 1922 After oil was struck outside the tiny hamlet of 100 people, the population quickly swelled to a tent city of 30,000. Seeking to make a profit off the oil workers and other immigrants, entrepreneurs soon lined Main Street with diners, stores, brothels, and gambling houses. The street itself, however, was often a muddy quagmire. Standing water here offered a mirror image of P. A. Griffin's Variety Store, Goldman's Store (advertising Elk Boots and a complete line of ladies wear), and the Army Goods Store, which shared space with a hotel. In today's tidy town of 2,000, none of these "boomtown" buildings remain.

El Dorado, 1908 The discovery of oil was still a dozen years away, and the sleepy timber town still accommodated horses and trees along the north side of its courthouse square. Though modified over the decades, this block remains intact. It stands as an example of what an Arkansas downtown can be in the post-downtown-shopping age.

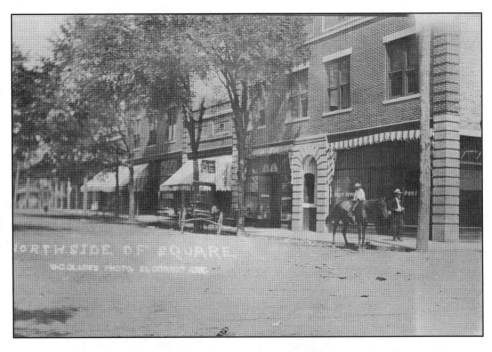

El Dorado, circa 1950 The Union County seat was well established as the oil capital of Arkansas, and the view of the north side of the square had changed greatly with the Lion Oil building looming in the distance. A close look at the arched door and windows shows that the building occupied by Hall's Drugs was present in 1908.

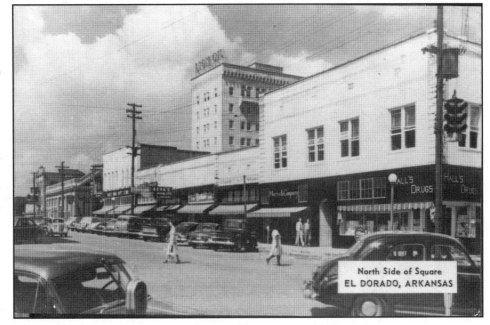

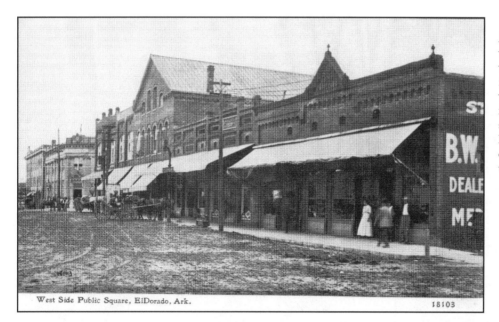

West Side Public Square, ElDorado, Ark. 18103

El Dorado, 1908 The west side of the square was anchored by pioneer merchant B.W. Reeves, whose department store fronted a muddy, rutted street. Most of this block has been replaced with other buildings over the years.

El Dorado, circa 1950 Forty years later, the west side of the square had changed markedly. Sterling had become the center of activity. The crowd on the right was buying jeans from a trailer. Now the entire block is proudly restored, part of a court-house square deserving of a drive to El Dorado for a walking tour.

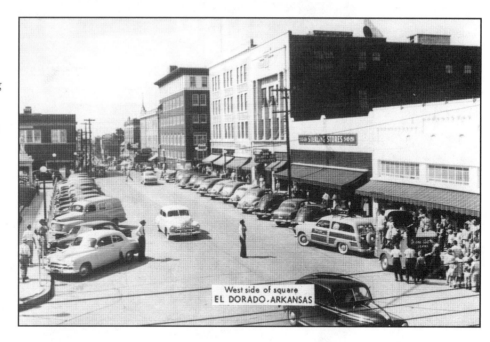

West side of square
EL DORADO·ARKANSAS

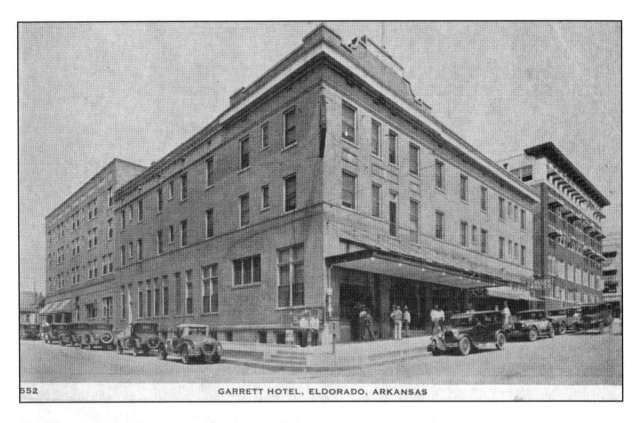

GARRETT HOTEL, ELDORADO, ARKANSAS

552

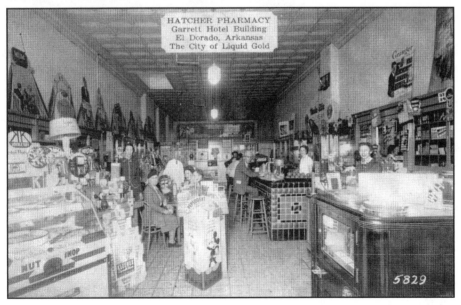

HATCHER PHARMACY
Garrett Hotel Building
El Dorado, Arkansas
The City of Liquid Gold

5829

El Dorado, circa 1935 and circa 1940 The four-story Garrett Hotel opened on the southeastern corner of the courthouse square around 1910. The photo below of the hotel's pharmacy and soda fountain labels the town "The City of Liquid Gold." During the oil boom of the 1920s, the hotel lobby became the center for trading oil leases. Business was so hectic that, for a time, cots were set up in the lobby. Long after the oil boom had settled down to orderly commerce, the hotel and especially its Hatcher Pharmacy and soda fountain remained a popular draw. The hotel was demolished some years ago; the corner is now home to a branch of BancorpSouth Bank.

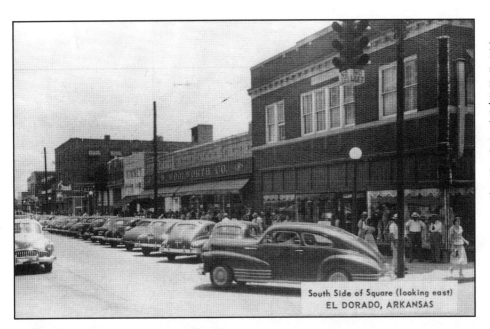

South Side of Square (looking east)
EL DORADO, ARKANSAS

El Dorado, circa 1950
Postcard views show the south side of the square from either end, the streets jammed with cars and the sidewalks with shoppers. Woolworth's drew traffic to the west end of the block, while the east end was anchored by the Hollywood Café. Although Woolworth's has faded into retail history and the café is long gone, the block is restored and vibrant, as is most of the downtown.

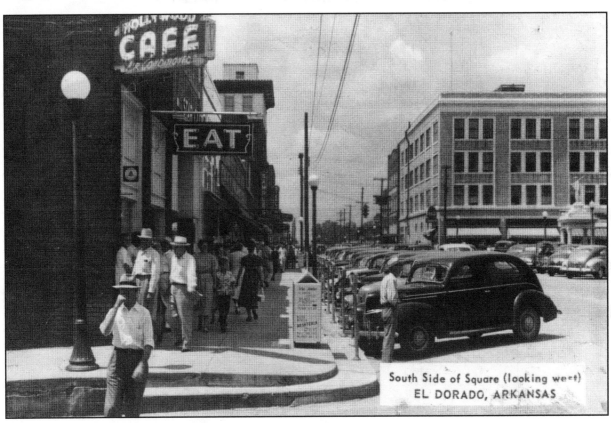

South Side of Square (looking west)
EL DORADO, ARKANSAS

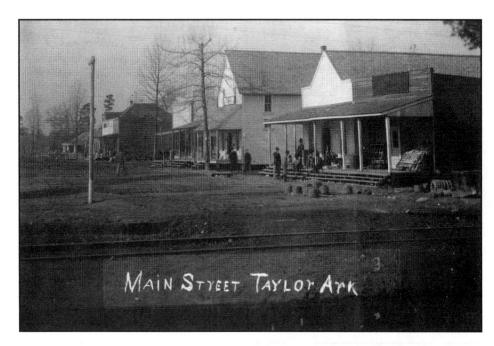

MAIN STREET TAYLOR ARK

Taylor, 1914 The tiny Union County town, located in the pine timber belt, sprouted its Main Street adjacent to the railroad tracks. The general store to the right would have likely received from a boxcar its stock of iron bed frames stacked on the porch and piles of fence wire still in the street in front of the porch. Today, all the buildings are gone.

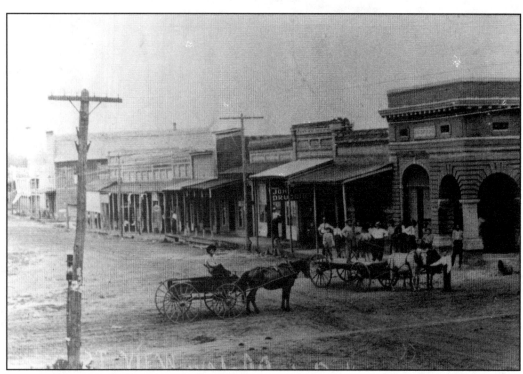

Waldo, circa 1910 The small Columbia County town, founded more than a century ago, is said to have gotten its name from a railroad freight agent. Waldo's heyday came during the oil rush of the 1920s. Today, 1,500 people call Waldo home. The bank and most of these buildings are gone. *(Photo courtesy of the Butler Center for Arkansas Studies)*

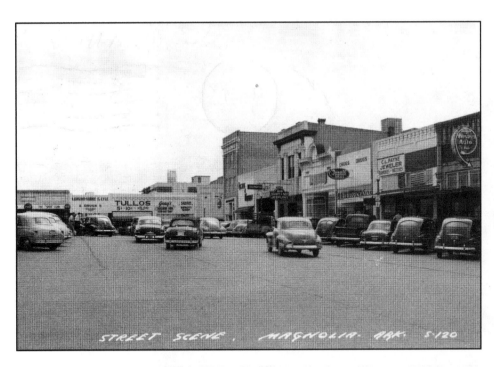

STREET SCENE, MAGNOLIA, ARK. S-120

Magnolia, circa 1950
The Columbia County seat's vibrant business district formed on all four sides of a venerable courthouse. Much of it still stands today thanks in part to shops serving students and faculty of Southern Arkansas University. This entire block survives, nicely restored. The two-story building in the center is a century-old former bank building that housed Bob Elliot & Son Jewelers in the post–World War II era. Today, the handsomely restored building is home to the Cosmopolitan Ladies Club.

Magnolia, circa 1950
The Joy Theater, on a block shared with Sterling, Kroger, and West Brothers department store, was showing *Cobra Woman* and *Feuding Rhythm*. The Joy is long shuttered, but most of the buildings survive, nicely restored and occupied. An attractively restored movie theater from the 1940s, the Cameo, does still operate a block off the square, showing first-run movies.

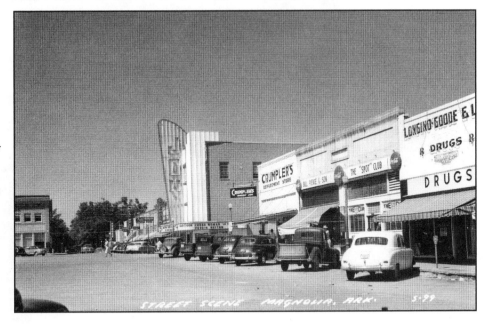

STREET SCENE MAGNOLIA, ARK. S-99

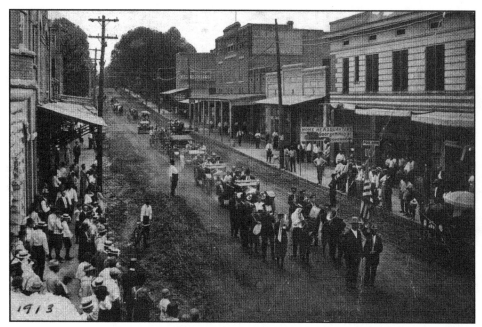

Camden, 1914 The parade on Adams Street was in honor of newly elected governor George Hays of Camden, seated in the front automobile. Hays was elected to succeed Joe T. Robinson, who had resigned to become a U.S. senator. Hays was perhaps best known for continually flip-flopping between supporting and opposing the prohibition of liquor. Today, most of the buildings still stand on the block, though many were covered in stucco-like siding beginning in the 1960s.

Hope, 1908 Forty years before the birth of Hope's most famous son, Bill Clinton, Main Street of the Hempstead County seat was lined with small shops and the Baptist church. Note the train station in the distance. Today, the church is gone, but several of the buildings survive, as does the depot housing a visitors' center and museum.

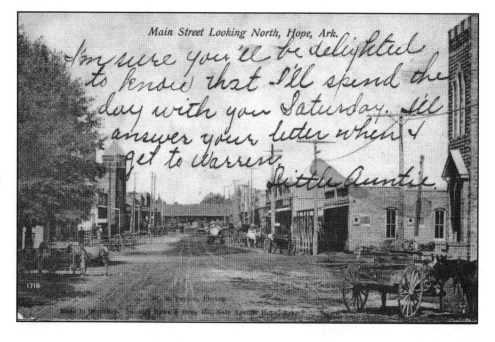

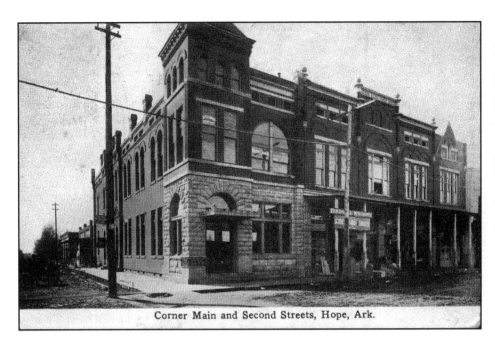

Corner Main and Second Streets, Hope, Ark.

Hope, 1911 and 2009
The two-story building at the corner of Main & 2nd streets was erected in 1891 to house the Hempstead County Bank. The building later served retailers, dentists, and lawyers. The restored building, minus some of the features that made it so elegant, today (2009) houses the Chamber of Commerce.

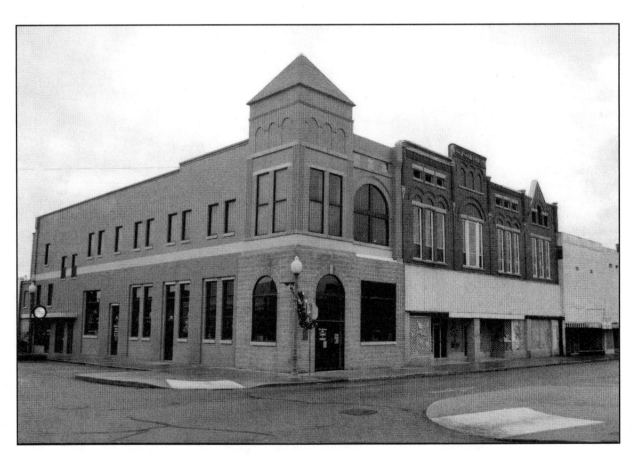

Hope, circa 1950 and 2009
The corner of Main and Highway 67 was the busiest intersection in town for many years, with motorists stopping at the Checkered Café, which had a checkered motif both inside and out. The street is largely intact today, but the checks are painted over, the building housing a Mexican market.

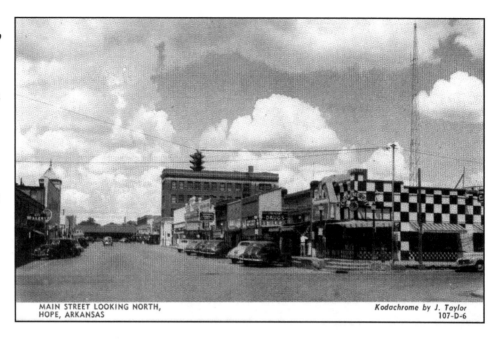

MAIN STREET LOOKING NORTH,
HOPE, ARKANSAS

Kodachrome by J. Taylor
107-D-6

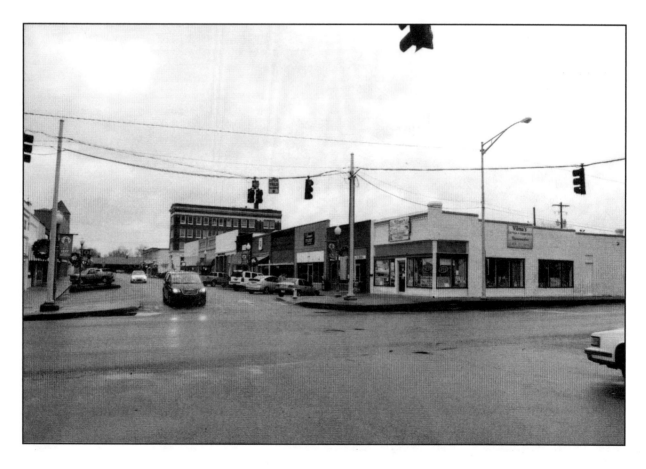

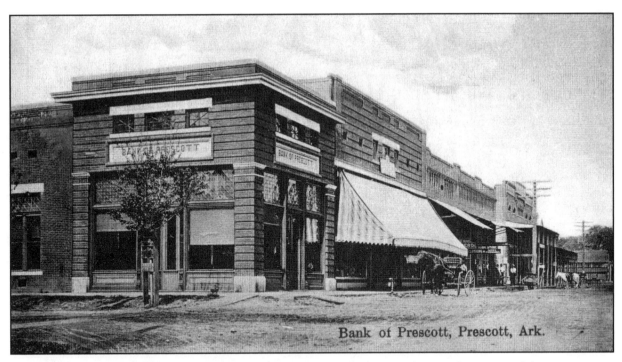

Bank of Prescott, Prescott, Ark.

Prescott, circa 1910 and 2009 A T-shaped confluence of Elk Street & 1st Avenue is home to the commercial district of the Nevada County seat. The commercial block of the packed-dirt street was anchored by the Bank of Prescott. Today, the bank still operates, but from a modern building two blocks away. Its former home is covered in siding, hiding its intricate brick work, and today houses the Teague Eye Clinic.

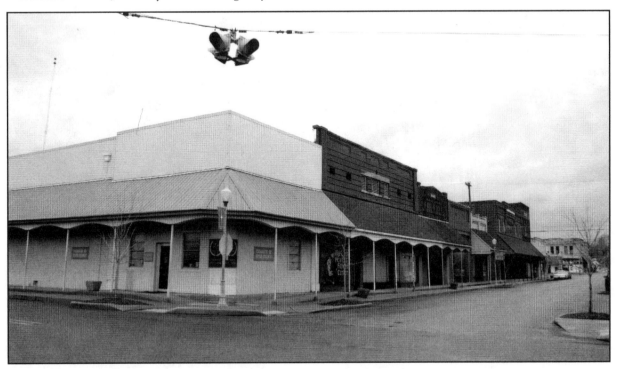

Prescott, circa 1945 and 2009 West 1st Street, also the path of Highway 67 before the coming of I-30, was the town's main artery. Sterling 5-10-25¢ store anchored the corner, while farther down the block was the D&D Café. In 2009, the Sterling building had been lost to fire and the traffic lost to I-30 a mile distant.

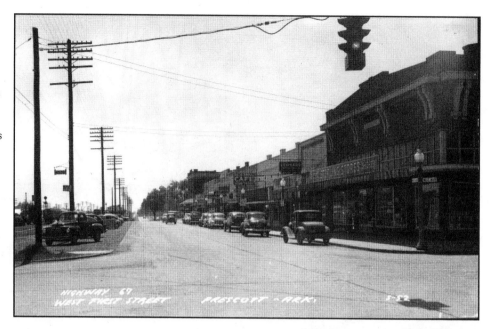

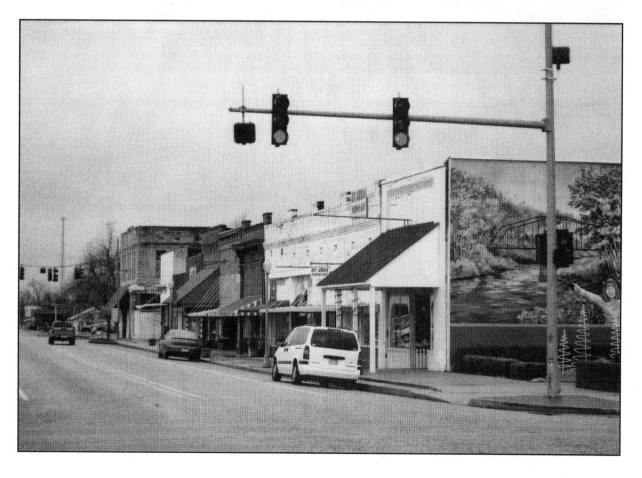

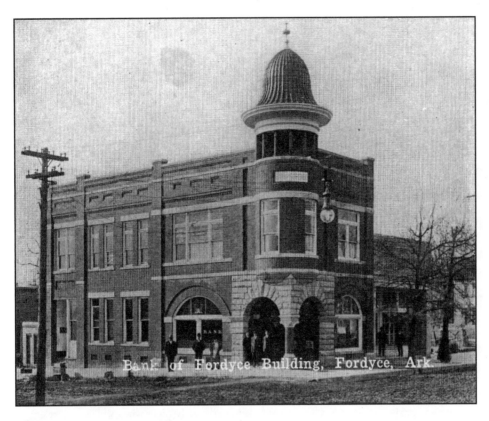

Bank of Fordyce Building, Fordyce, Ark.

Fordyce, 1908 and 1998
Among the most striking buildings on Main Street was the Bank of Fordyce. A century later, the building survives but without its ornate turret and cupola. It has become a jewelry and upscale gift shop. The friendly shop owner likes to show off the polished marble columns, now visible only inside the building.

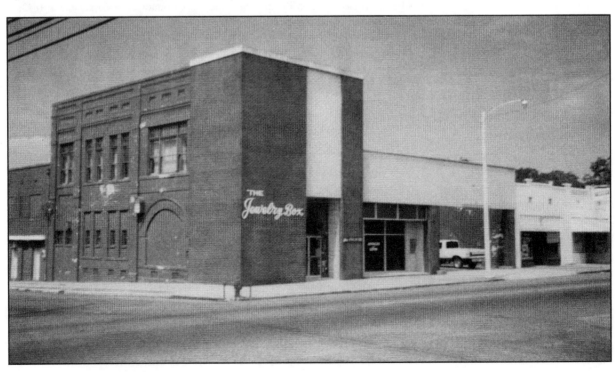

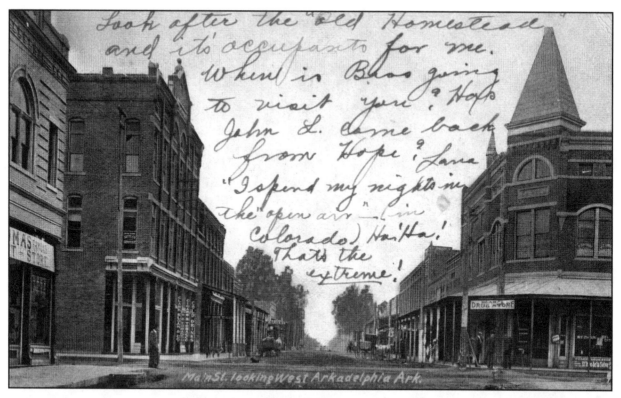

Look after the "old Homestead" and it's occupants for me. When is Bess going to visit you? Has John S. come back from Hope? Lana "I spend my nights in the "open air" (in Colorado) Ha! Ha! That's the extreme!

Main St. looking West Arkadelphia Ark.

Arkadelphia, circa 1910 The community that became the Clark County seat dates to the early 1800s when William Blakeley built a blacksmith shop on a bluff overlooking the Ouachita River. The spelling of the Clark County seat, incorporated in 1843, was in some records originally as Arcadelphia, leading—in later years—to speculation that the name was coined by joining a rainbow "arc" with part of Philadelphia. By 1908, the still-dirt Main Street had become the most photographed place in town for postcards, especially the E. H. Hall building to the right.

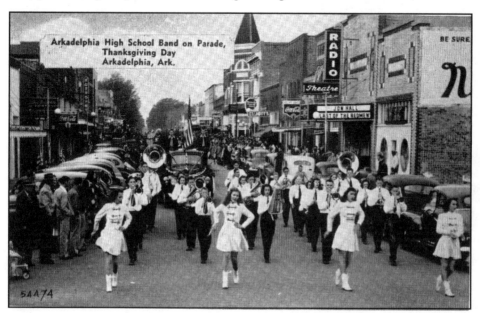

Arkadelphia High School Band on Parade,
Thanksgiving Day
Arkadelphia, Ark.

Arkadelphia, circa 1947 The high school band was parading down Main Street a block south of the view above, the street now paved in the two-college town. The Radio Theatre was playing *Last of the Redmen.* Most of this block, including the theater, is gone today.

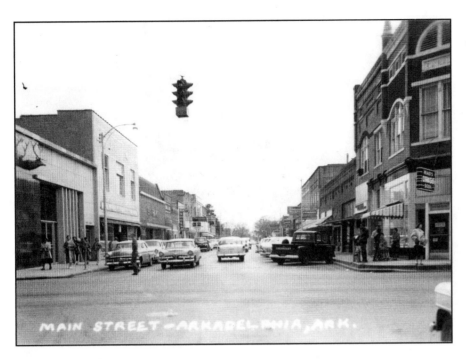

MAIN STREET—ARKADELPHIA, ARK.

Arkadelphia, circa 1957 and 2009
In 1884, recognizing the growing community's need for a bank, merchant S. R. McNutt and bookkeeper John Stuart pooled their money and organized the Elk Horn Bank. Opened with total assets of $3,000, it moved to this location on the corner of 6th & Main in 1903, where it continued a half century later, with its trademark elk-head replica still mounted on the front of the building. The building is now home to Southern Bancorp Bank of Arkansas, and the bank still operates under the elk's head even today. The E. H. Hall building on the right burned years ago; a small park occupies the corner.

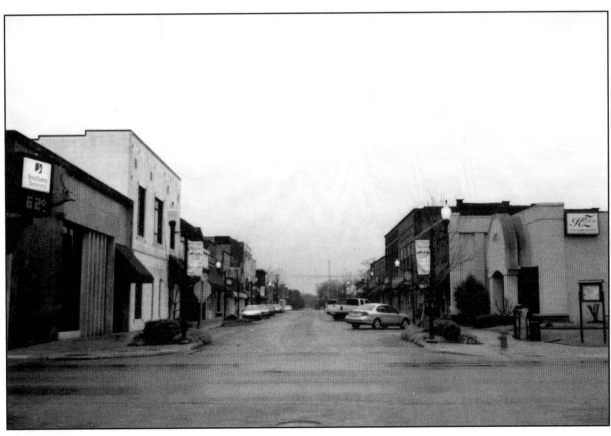

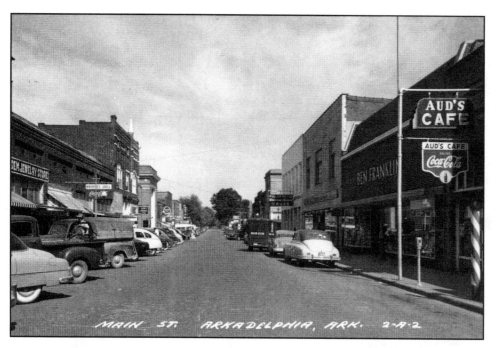

Arkadelphia, circa 1955 Today, most of the left side of Main is largely gone or replaced, but the right side is still intact where Ben Franklin and Aud's Café have been succeeded by different enterprises.

Gurdon, circa 1957 The small town built on timber was home to the Hoo Hoo theater (named for a legendary ghost said to have walked the train tracks). On the day this view was photographed, the theater with the eerie name was showing *Scared Stiff* and *Jumping Jacks*, both comedies starring Dean Martin and Jerry Lewis. Today, the theater building is gone, but most of the rest of the block is still intact.

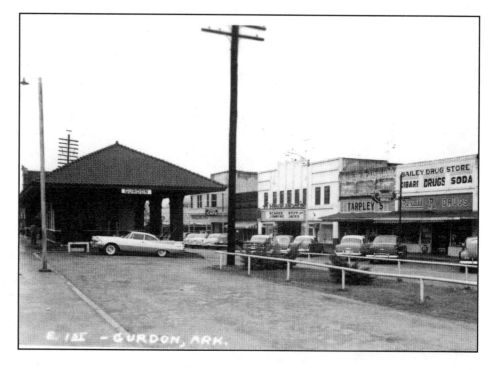

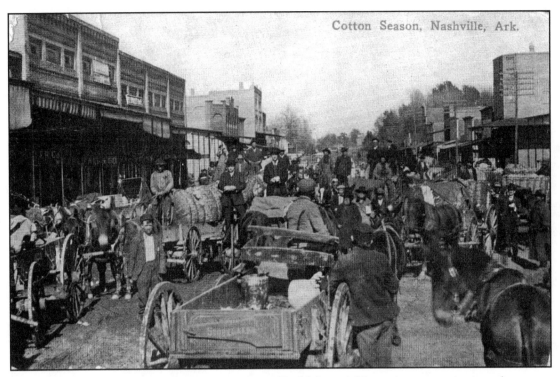

Nashville, circa 1909 and 2009 Cotton, once grown in 73 of Arkansas's 75 counties, was a mainstay on the small farms of Howard County. Here, farmers bring their crop to town to sell to buyers on a jammed Main Street. A century later, the buildings are almost all intact and occupied.

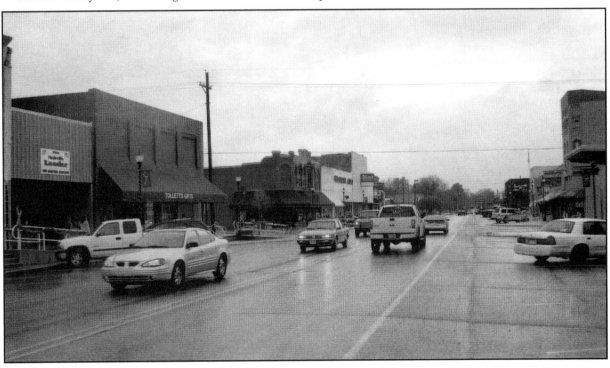

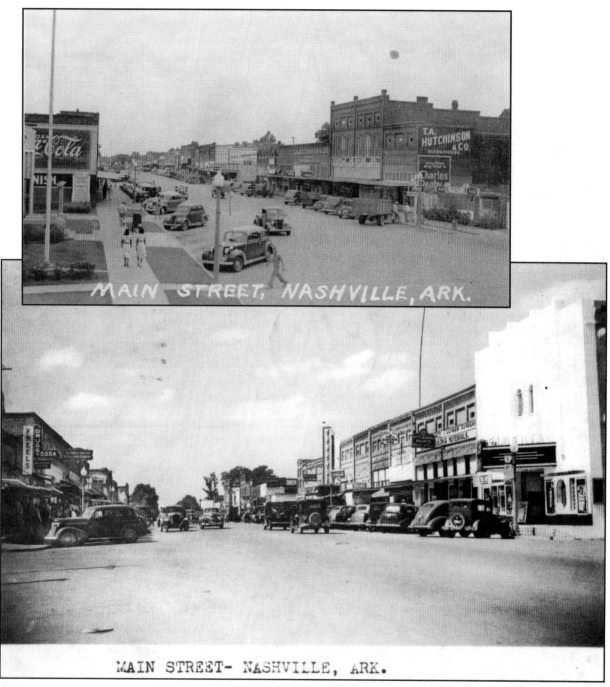

MAIN STREET, NASHVILLE, ARK.

MAIN STREET- NASHVILLE, ARK.

Nashville, circa 1940 The upper end of Main Street was home to the post office, just out of sight to the left of the scene in the top postcard looking down several blocks of bustling commerce. The largest building across the street to the right was home to Nashville Hardware Co., neighbor to T. A. Hutchinson & Co. Feed & Groceries. Today, all the buildings seem intact and occupied. A number of the buildings, as was the fashion beginning in the 1960s, were covered by siding that hid often-intricate brickwork. The photo below, taken at the opposite end of the street, captured the Elberta Theater (named for the famed peaches grown in the area). The theater was razed years ago. The site is today a funeral home parking lot.

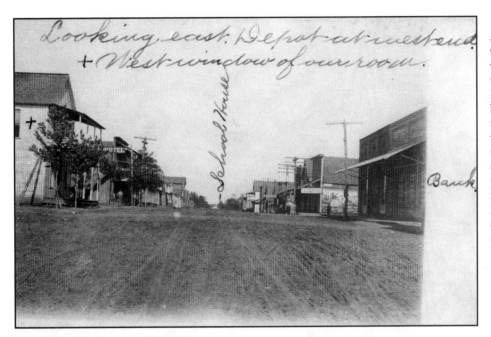

Looking east. Depot at west end. + West window of our room.

School House

Bank

Horatio, 1911 The Sevier County town of 970 people was founded in 1898 along the Kansas City Southern Railroad, only 13 years before this postcard of the wide, dirt Main Street was mailed. In addition to marking the depot and school house, the writer penned, "I rode out about 5 miles from town on horseback yesterday." None of the frame business district survives today.

Womble, 1917 The Montgomery County village was founded in 1907 and named for a family who assembled the land with the intent of establishing a timber business. In the 1920s, after a falling out with the Womble family, the townspeople renamed it Norman. Today, the name has reverted to the original, and the population stands at 400. The short business block seen here in 1917, including the once-popular Ice Cream Parlor, is long gone.

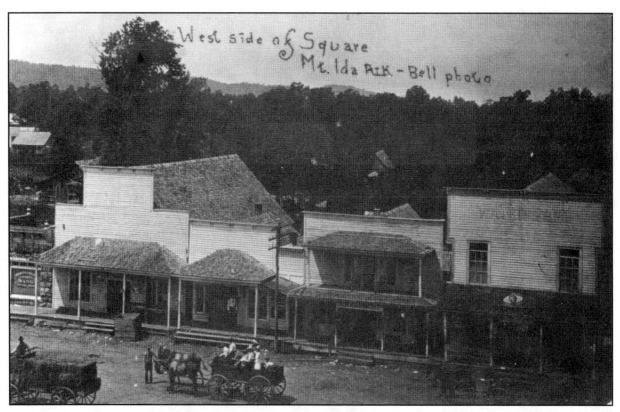

Mount Ida, circa 1900 First named Montgomery, then Salem, and finally Mount Ida around 1850, the county seat of Montgomery County developed a business district around its courthouse square. The long row of wooden stores, seen here from the courthouse, was gone well before mid-century.

Mount Ida, circa 1930 "Road n. in bad shape, best route Mena, Waldron, Fort Smith by 27 & 71" read the sign in the middle of the snow-packed courthouse square. The men to the left are standing in front of what was apparently the tourist information center.

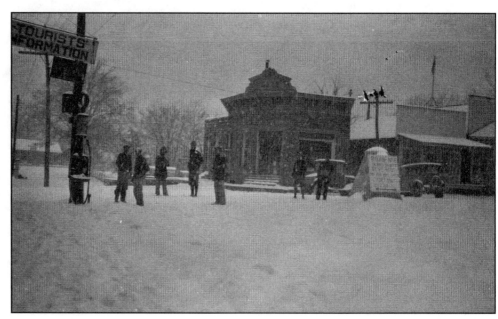

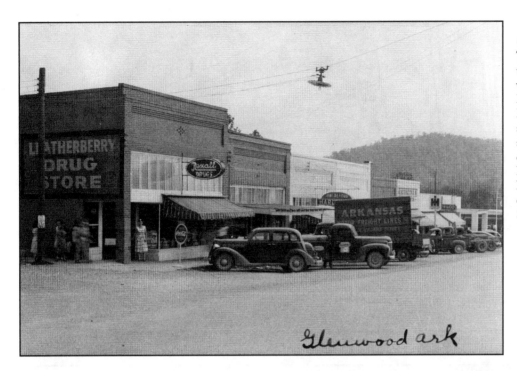

Glenwood, 1949
The Pike County town's Main Street was home to Leatherberry's Rexall drug store—a loosely franchised arrangement of the day—Tom Alford's Hardware, the International Harvest dealership, and a Citi Services gas station.

Glenwood ark

DeQueen, 1907
The Sevier County seat downtown had been destroyed by fire in 1899. Its juncture on the Kansas City Southern Railroad prompted a rapid rebuilding around the courthouse square. "This is the worst looking corner in town," penned a young man regarding the block that housed Burson the Buggy Man and the J. Greenwald Dry Goods store. The block survives today, although with alterations.

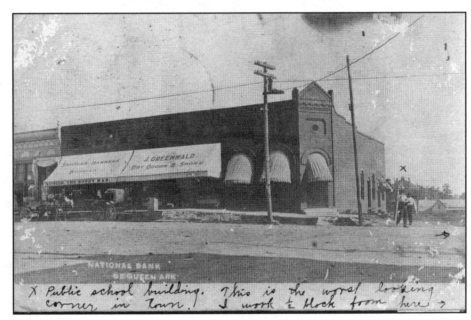

X *Public school building. This is the worst looking corner in town. I work ½ block from here* →

DeQueen, circa 1910
"This is DeQueen Avenue," wrote the correspondent; "Hope you will appreciate this view. We have a good town." The town, named for railroad financier John DeGoigen of the Netherlands, found its square packed with farmers' wagons and one automobile on the day this image was snapped. Most of the buildings, especially the striking Bank of DeQueen to the distant left, stand on the square today.

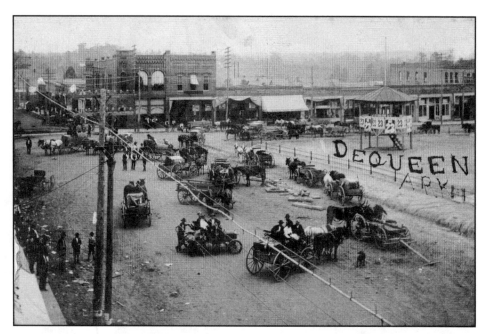

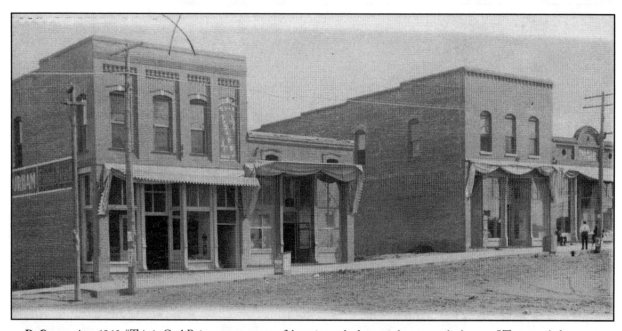

DeQueen, circa 1910 "This is Carl Raines grocery store, I have it marked, certainly a pretty little store." The penciled, century-old message shows that Main Street met perhaps all shopping needs at the time. Today, the town, which is home to a large Hispanic influx, finds its once-thriving downtown isolated from shopping centers and discount stores clustered out on Highway 71.

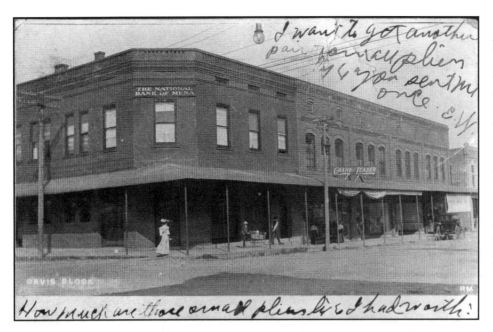

I want to get another pair of [those?] pliers [like?] you sent me once. E.W.

How much are these small pliers &c I had worth!

Mena, circa 1910 and 2009
"Hello Archie, did you ever see this place before?" The writer referred perhaps to the National Bank of Mena before which a young boy paused with a baby carriage, looking back at his mother trailing behind. Seen below a century later, the building is almost unrecognizable, its upper floor removed, and the remainder boarded up and vacant. The buildings just beyond have been replaced.

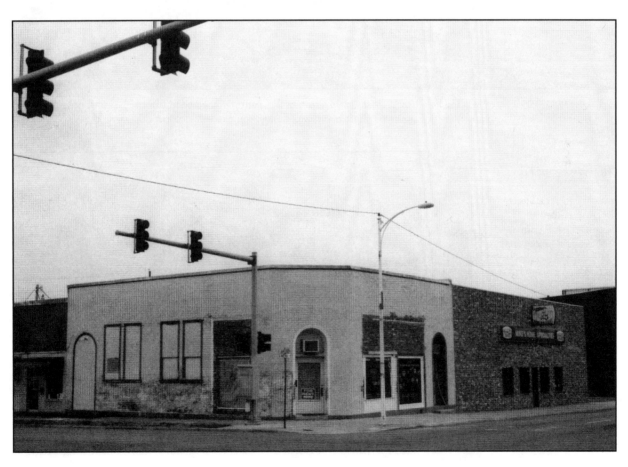

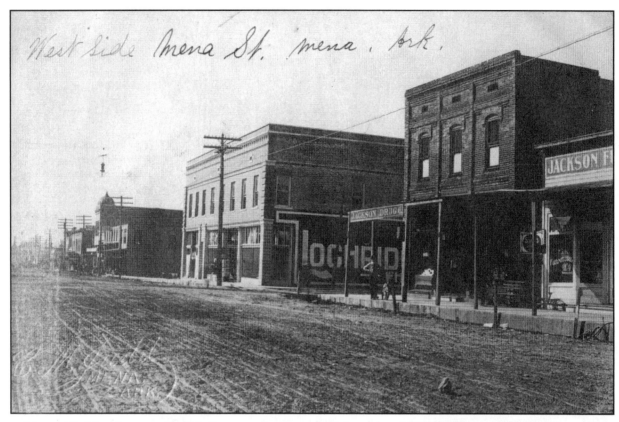

Mena, 1907 Mena Street was the Polk County seat's main street, its dirt path well marked in front of Jackson's drug store and Jackson's Furniture. A portion of these buildings survives, though some have lost upper floors over the years.

Mena, 1908 The Fraternal Order of Elks hosted a parade on Mena Street where a mother was turning a small pony cart carrying herself and children. Next to the Leader department store was Eselco, offering ten-cent cigars. Most of the retail commerce in Mena today is a few blocks north of Mena Street on Highway 71. Mena Street has worked to redevelop, with antique shops and one of the best second-hand bookstores in Arkansas, Books and Stuff.

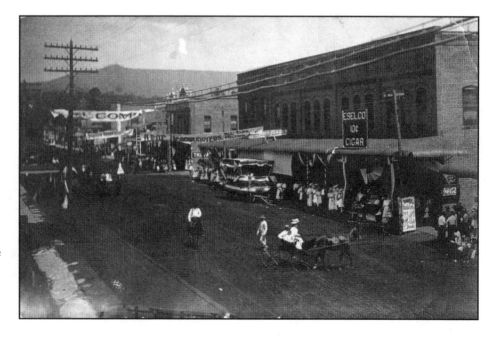

Mena, circa 1930
The horse and buggies marking the street in the last few photos had faded into history by 1930. The automobile age had created business for the "Open Day and Night" P&M Service & Café located at one end of Main Street.

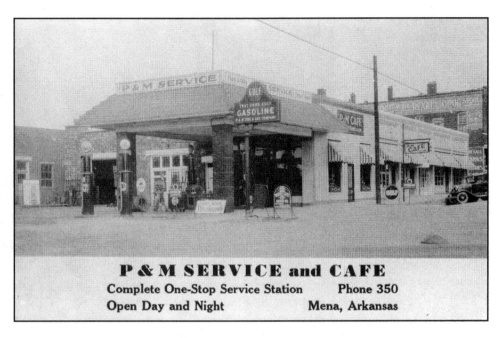

P & M SERVICE and CAFE
Complete One-Stop Service Station **Phone 350**
Open Day and Night **Mena, Arkansas**

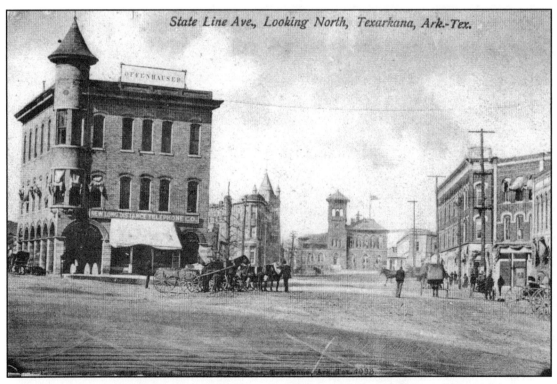

State Line Ave., Looking North, Texarkana, Ark.-Tex.

Texarkana, circa 1905 The Miller County seat's State Line Avenue, with Texas on the west (left) and Arkansas on the east (right), was the most-photographed street in southwest Arkansas. In the distance, the Federal Courthouse straddled the state line. The Offenhauser Building to the left was built in 1879 and added to over the years. Today, it is wonderfully restored and is home to the Texarkana Regional History Museum.

Texarkana, circa 1925 The view looks from Broad Street, Texarkana's major retail street for decades, split between Texas and Arkansas, north up State Line Avenue. The Texarkana National Bank building to the left has been replaced, while the State National Bank on the opposite corner had a much different fate. When the bank relocated in 1971, the Ben Smith Department Store moved in, putting what has been described as a "slip cover" over the building, completely changing the look. Today, it is known as the Landmark building and houses a variety of tenants.

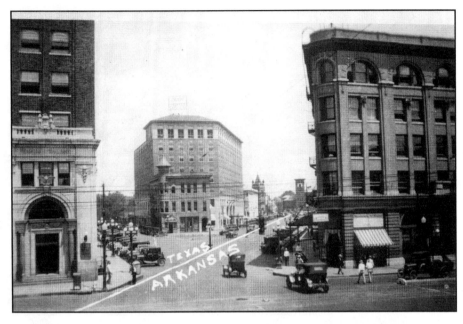

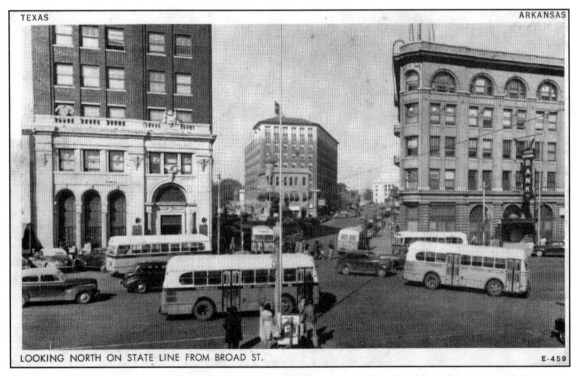

Texarkana, circa 1945 Twenty years after the photo above, the intersection of Broad and State Line remained the crossroads of the border city jammed with buses and cars. The towering building in the distance, behind the Offenhauser building, is the Hotel Grim, which was the finest hotel in the city after its 1925 construction. Today it stands boarded up, windows gaping, with off-and-on efforts to restore its grandeur for other uses. Most of the retail trade has left downtown for shopping centers closer to Interstate 30, leaving the future of many downtown buildings a challenge for the community.

118

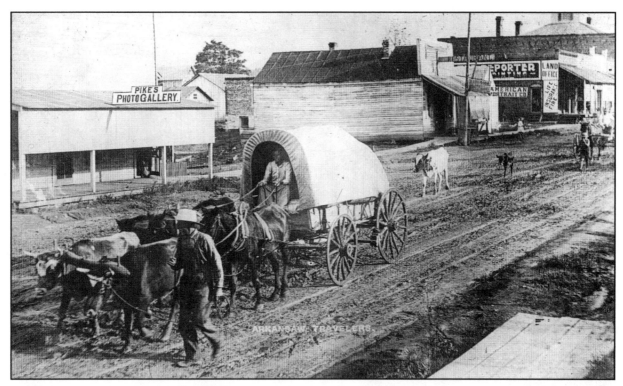

Waldron, circa 1900 Incorporated in 1852, the Scott County seat remained a remote Ouachita Mountain village into the twentieth century. Its muddy Main Street was the path for a covered wagon pulled by a yoke of oxen and a team of either horses or mules behind the oxen.

Waldron, circa 1912 Buildings of brick and native stone had begun to rise on Main Street, housing such businesses as E. E. Pinnell Jewelry & Musical Instruments. Note the rough plank walk spanning the street that would have allowed passage between the stores and the courthouse.

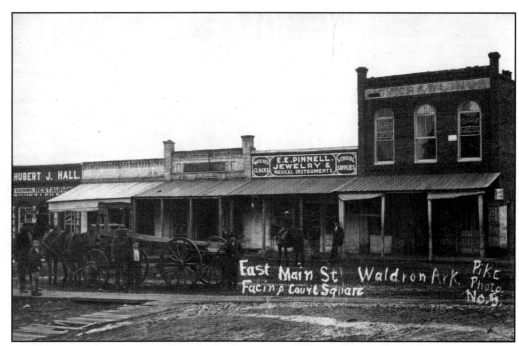

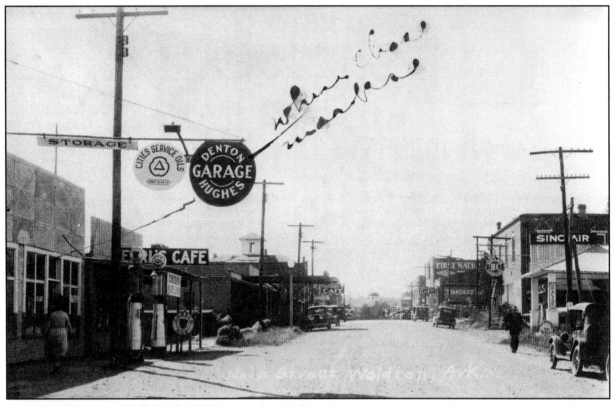

Waldron, 1922 "Where Chase works." The man made his living at Denton & Hughes Garage, which according to a sign over the pumps, also sold chicken plate lunches to Main Street patrons. The business competed with the Sinclair gas station across the unpaved street.

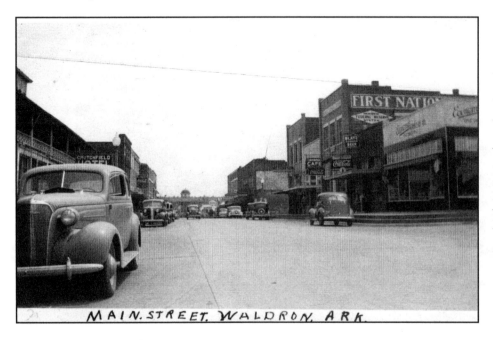

Waldron, circa 1940 Before Scott County went dry, a patron of the Crutchfield Hotel on the left could have walked across Main Street to enjoy a Blatz beer, advertised along with two signs for Coca-Cola. With the exception of the Baptist church in the far distance, the street is largely intact today. To visit the very interesting Main Street, today's motorist need only take the Highway 71 Business Loop away from the traffic on Highway 71.

NORTHWEST ARKANSAS

The northwest portion of Arkansas was for decades a collection of small towns, remote villages, and few people. Even Fayetteville, home of the University of Arkansas, recorded only 5,362 people in 1920, all of Washington County only 39,255 in 1930. In the early part of the twentieth century, it was home to the Victorian resort of Eureka Springs and orchards that led the nation in apple production. Northwest Arkansas is, in many ways, a changed place today with its booming economy and population influx. But a lot of Main Street history remains to explore. The rich diversity of the communities scattered over the mountains and valleys, and especially the towns' Main Streets, was captured on picture postcards that provide a window back in time.

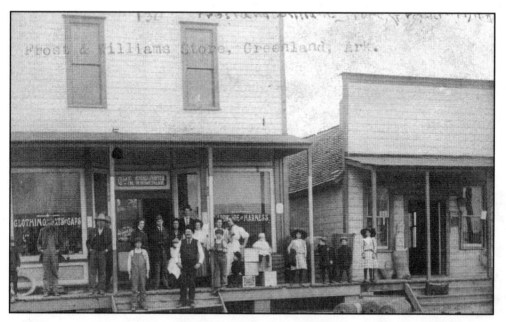

Greenland, 1911 Today, the tiny town blends into the southern edge of Fayetteville, but a century ago, it was a very independent village a short wagon ride away which boasted its own Main Street. Anchoring the short business block was Frost & Williams Store advertising "COME IN: Small profits is what talks." The buildings have been gone for decades.

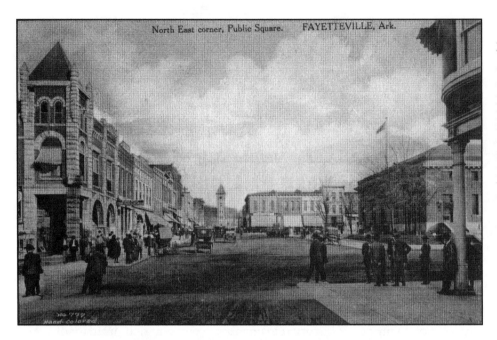

North East corner, Public Square. FAYETTEVILLE, Ark.

Fayetteville, circa 1905
The Washington County seat's main retail blocks came to be formed in a public square around the post office seen to the right. Over the decades, as portrayed in the next few photos, the most-photographed-from vantage point was looking up Center Street toward the county courthouse seen in the distance.

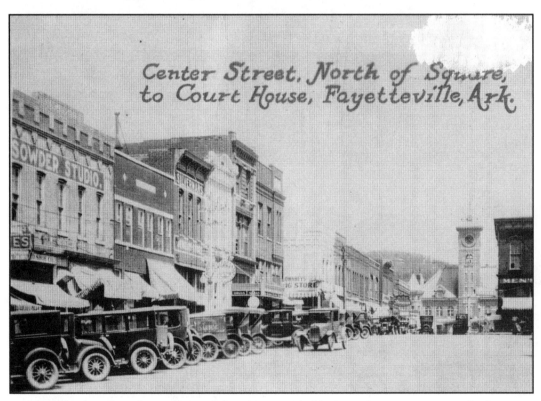

Center Street, North of Square, to Court House, Fayetteville, Ark.

Fayetteville, circa 1920 Center Street and the public square had been paved in 1921, just in time for the flood of automobiles that the decade would bring into downtown. According to the clock in the courthouse tower, the photo was taken at 1:20 in the afternoon on a day when available parking spaces were scarce.

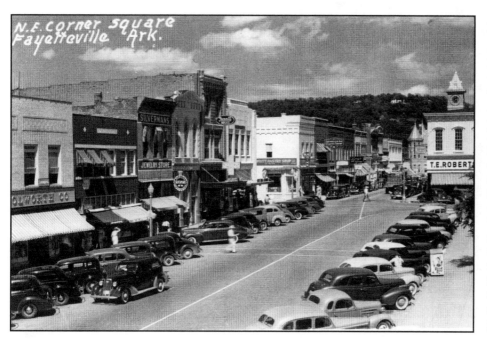

Fayetteville, circa 1940
The view looking east on Center toward Mount Sequoyah found the buildings virtually unchanged from the view 20 years earlier seen on the previous page. Woolworth's had opened to the left, but Silverman's Jewelry Store still occupied the center of the block just as it had in 1920. Just up the block on the corner was the Bob White diner and pastry shop. A movie poster is displayed on the sidewalk to the right promoting the film *The Torrid Zone*, which starred James Cagney as a South American banana plantation owner.

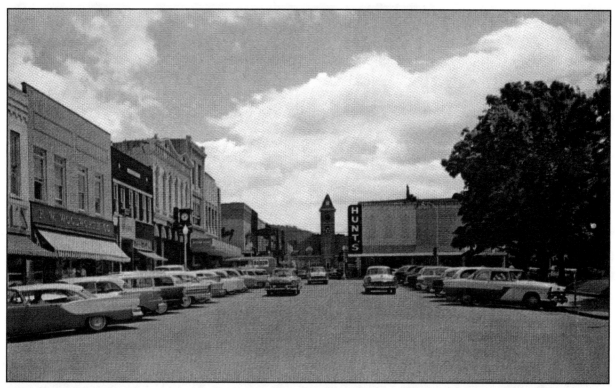

Fayetteville, circa 1957 The cars had changed over the decades, but the buildings had survived. Woolworth's still occupied the block, with Hunt's department store opposite across the square. Today, almost all the buildings on the left have been replaced, and what little remains is so altered as to be unrecognizable. The 1904 Washington County courthouse, however, still stands.

Springdale, 1910 A large spring located in the middle of town gave the Washington County community of Shiloh its new name in 1875. Some 35 years later, its main business street became Emma Avenue, unpaved but lined with blocks of brick and stone commercial buildings.

Springdale, 1911 One family had parked its wagon under a shade tree, while other shoppers were loading their wagon at Regan Brothers Dry Goods & Groceries. The grocery store shared the handsome building with a bank.

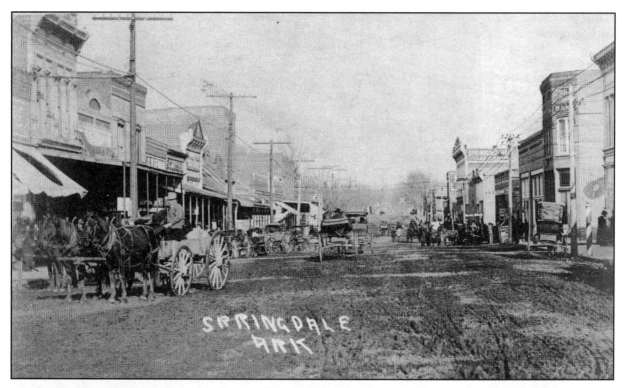

Springdale, circa 1910 Emma Avenue was muddy after a rain, wagon ruts evident on the wide business thoroughfare. The city had only about 2,000 people at the time but was home to several canning factories, among other enterprises.

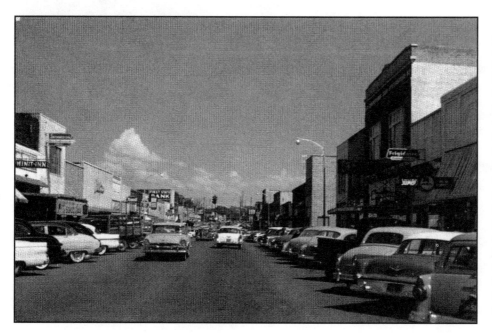

Springdale, circa 1957 Emma Avenue was still the place to shop, as busy Highway 71 passed just to the western end of the street. Shopping centers were taking hold on the outskirts, and urban renewal—beginning in the 1960s—would replace a number of the historic older buildings. Looking at this photo and the preceding ones of Emma Avenue, readers will notice that new, low-maintenance façades covered or necessitated removal of original architecture.

Lincoln, circa 1910

The farming community, surrounded by orchards a dozen miles outside Fayetteville, developed its small business district around Park Street above and Adams Street below. On Park, the Hotel Lincoln was selling meals for 25 cents while J. M. Smith's Hardware and Furniture in the stone building competed with Brown's Cheap Store at the end of Adams Street. The stone building that housed Smith's was torn down several years ago to make room for a branch of Simmons Bank.

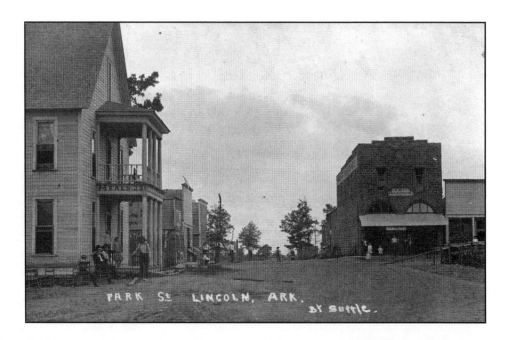

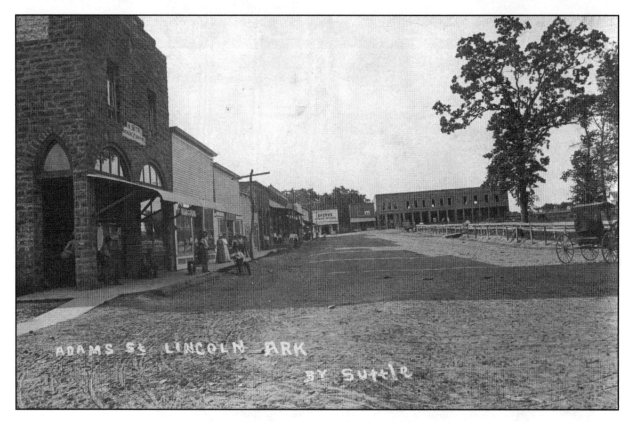

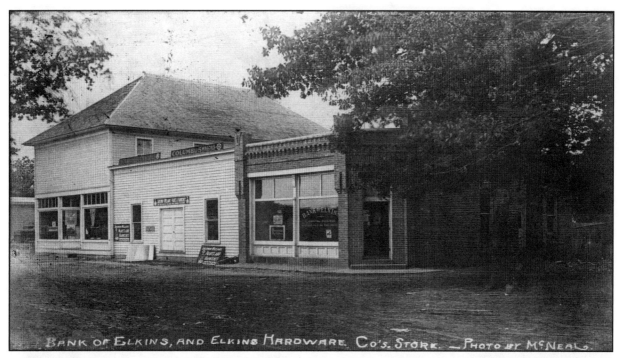

BANK OF ELKINS, AND ELKINS HARDWARE. Co's. STORE. — PHOTO BY McNEAL.

Elkins, 1915 The business district in the small Washington County hamlet was modest, anchored by the sturdy brick Bank of Elkins, which sat next to the wooden-framed hardware store advertising Sherwin Williams Paint and Columbus Wagons. Only the bank building survives today, boarded up; its neighboring stores are long gone.

Ponca, 1910
In the remote mountains of Newton County, which had no paved roads for decades, the tiny village of Ponca's rough main street was apparently being improved by men with shovels and rakes. The town's principal business was L. G. Young's general store, which was advertising American Gentlemen and American Lady Shoes, Horseshoe Tobacco, and Star Tobacco. The store is long gone, but Ponca businesses cater to thousands of Buffalo National River visitors each year.

Spring Street, Eureka Springs, Ark.

Eureka Springs, 1914 and circa 1957 The Victorian-era resort town was incorporated in 1880 with its chief thoroughfare being the aptly named Spring Street. In the 1914 view above, the trolley tracks came down the steep street, passing the Basin Park Hotel on the left and the Flat Iron building on the right, home to the Frisco Bar. By the time of the circa 1957 view below, the trolley tracks were gone and the Flat Iron building had been lost to fire, but the site is today home to a replacement very much resembling the original. The Basin Park Hotel still serves guests today, having provided more than a century of hospitality.

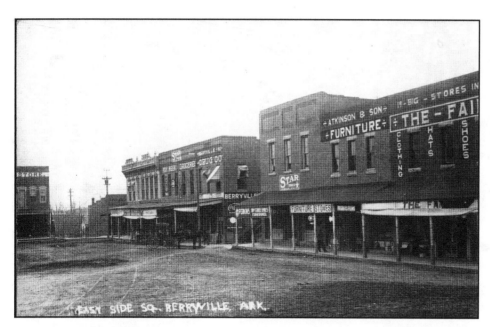

Berryville, circa 1910
The town was founded in 1850 and came to share Carroll County seat honors with Eureka Springs. Its retail district grew up around its courthouse square, the east side of which was home to such places as Atkinson & Son Furniture, a general store named The Fair, and a pharmacy. Today, the block is largely intact and restored.

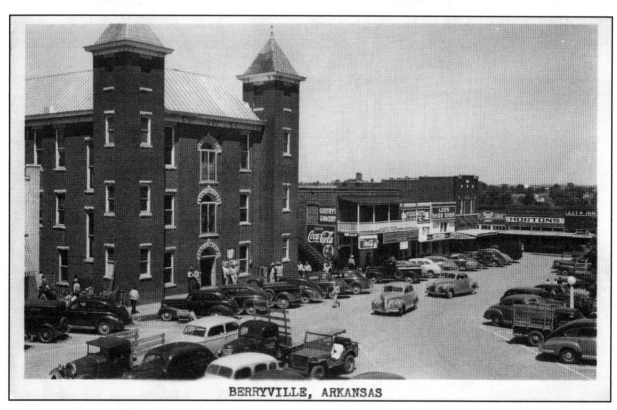

BERRYVILLE, ARKANSAS

Berryville, circa 1945 The western side of the square, in front of the 1890 courthouse, was jammed with traffic, drivers perhaps shopping at Oklahoma Tire & Supply or Gentry's Grocery. The courthouse still stands, though the county's business has moved to a newer building around the corner.

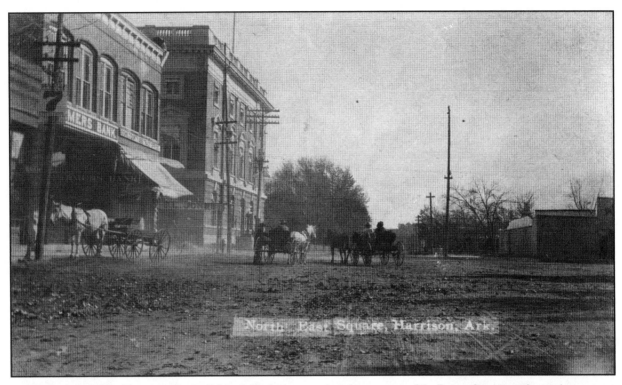

Harrison, circa 1910 The intersection of Main & Rush streets anchored one corner of the Boone County seat's courthouse square business district. Almost a century later, the former federal building and post office still stand, though empty. The former Farmers Bank building's arched windows have been bricked over, and the building is today home to a commercial business.

Harrison, circa 1935 The Great Depression had left its mark on both the people and buildings of downtown. The New Model Grocery next to the corner Security Bank bears a sign with the blue eagle symbol and the title NRA for National Recovery Act. Farther down the block, a sign reading "Relief Commissary" hangs over the sidewalk, next to the Coca-Cola sign of City Drug.

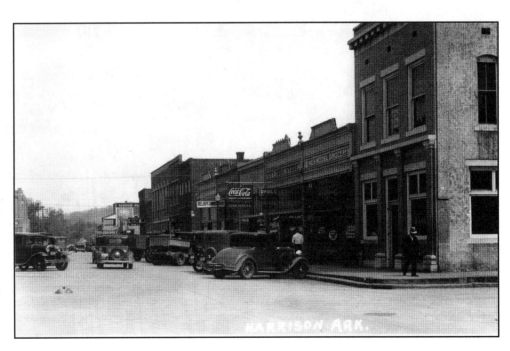

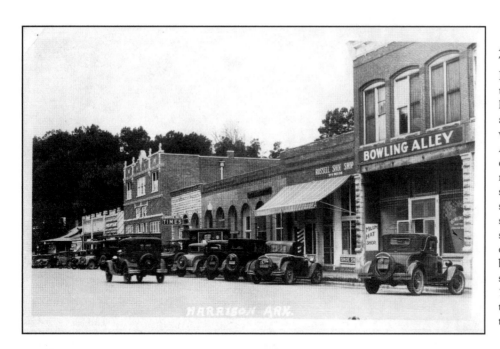

Harrison, 1933 and 1998
The former Farmers Bank building seen on the previous page in 1910 had become a bowling alley, sharing the block with a shoe shop, the *Harrison Times,* and the ornate Lyric movie theater rising farther down the street. Six decades later, seen below, the block was still intact, but the most striking features of most of the buildings had been bricked over, including the stonework at the *Harrison Times* building next to the proudly restored Lyric theater.

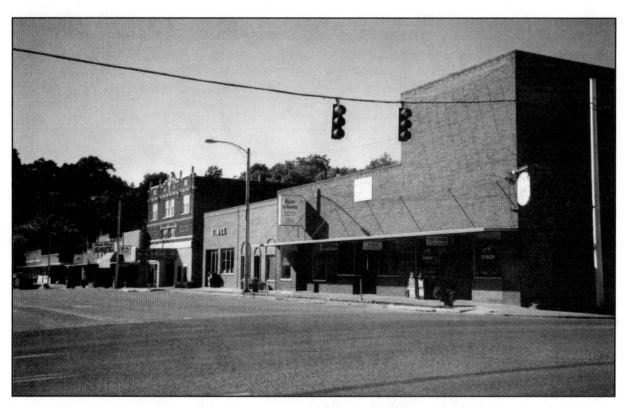

Harrison, circa 1945 and circa 1957 North Vine Street, on the east side of the square, was anchored in the mid-twentieth century by Walters Dry Goods Co. on the corner and Ben Franklin's just up the block. The busy block faced the 1909 Boone County Courthouse. Today, the block is intact, as is almost all the historic, nicely preserved downtown.

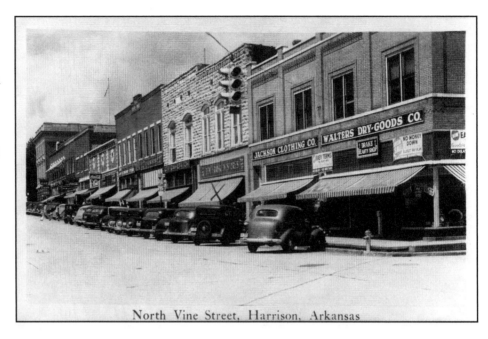

North Vine Street, Harrison, Arkansas

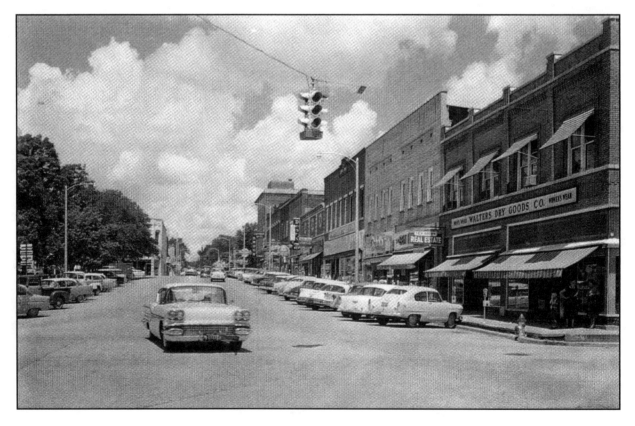

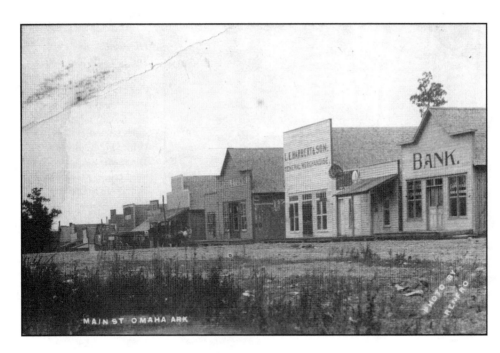

Omaha, circa 1910
Today, the northern Boone County community is just a sign on busy Highway 65 offering a chance to buy gas and snacks. A century ago, its Main Street more resembled the set of a Hollywood Western, with the bank at the right advertising that it had $10,000 in capital to work with. No trace of the buildings remains today.

St. Paul, circa 1900
The tiny Madison County Ozark mountain village profited from harvesting white oak timber for barrel staves and railroad ties. At the center of the block, one business advertises lodging and meals "at all hours." *(Photo courtesy of the Butler Center for Arkansas Studies)*

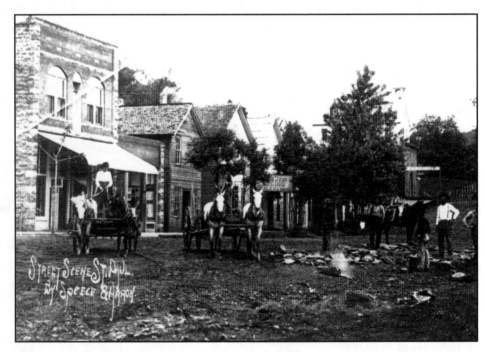

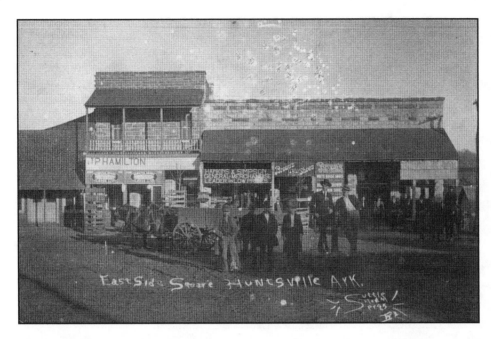

Huntsville, circa 1910
The east side of the square in Huntsville, the Madison County seat, was home to at least two general stores that heavily advertised shoes, including Brown's White House Shoes. The town was named for John Hunt, a settler from Tennessee in the early 1800s.

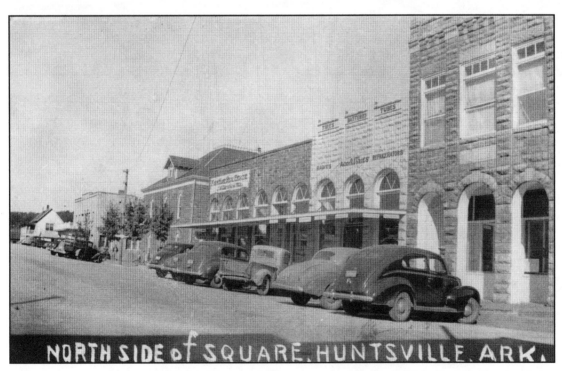

Huntsville, circa 1945 Native stone construction and striking use of arched doors and windows—hallmarks of better buildings constructed in northwest and north-central Arkansas during the first two decades of the twentieth century—were still much in evidence in this World War II–era scene. Note the middle building advertising tires, batteries, tubes, radios, and refrigerators. While most of the square's historic buildings still stand, beginning in the 1960s, most were covered in siding or stucco, the most interesting features covered up.

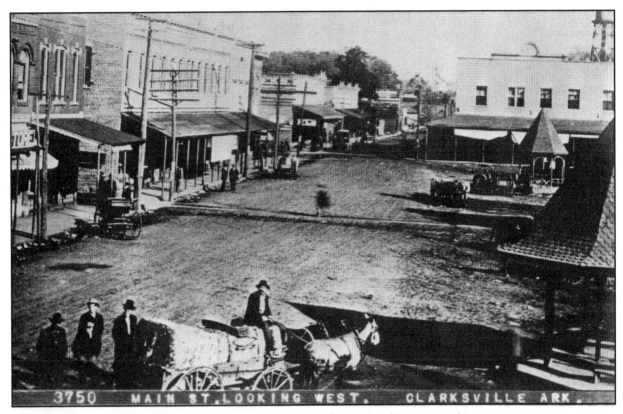

3750 MAIN ST. LOOKING WEST. CLARKSVILLE ARK.

Clarksville, circa 1910 The Johnson County seat was incorporated in 1848 and became a coal-mining center by the time Main Street was photographed with the gazebos flanking the courthouse lawn.

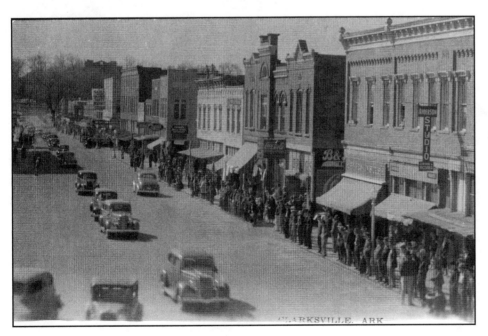

CLARKSVILLE. ARK

Clarksville, circa 1945 Main Street witnessed a parade passing its historic buildings, perhaps to honor World War II troops. Anderson photo studio, which made this postcard, shared the building to the right with the Ben Franklin store. Though impacted by time, alterations, and fires, many of the college town's downtown buildings still stand.

Marshall, circa 1920
The Searcy County seat's main streets wrapped around the courthouse just out of sight to the left. A garage owned by Buck Mays (note its Conoco gas pumps) serviced the slowly growing number of autos in a county that had no paved roads at the time.

Leslie, 1912 "Beautiful, is it not?" is written on a postcard of the intersection of Main & Oak streets. The small town is located a few blocks east of modern Highway 65; the corner bank building with the Coca-Cola sign still stands.

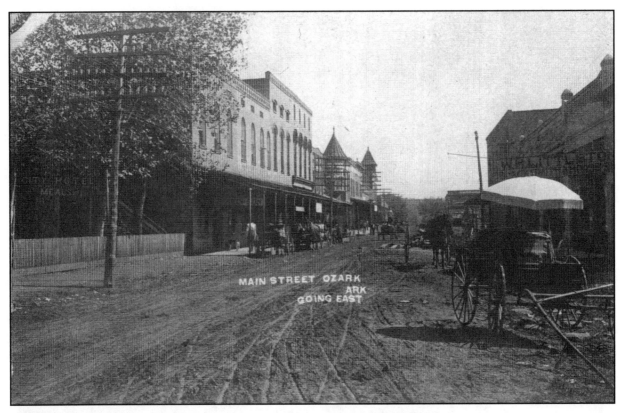

Ozark, 1907 Among the Main Street businesses was W. H. Littleton's blacksmith and horse-shoeing shop to the right just above the umbrella that appears to shade a client's buggy.

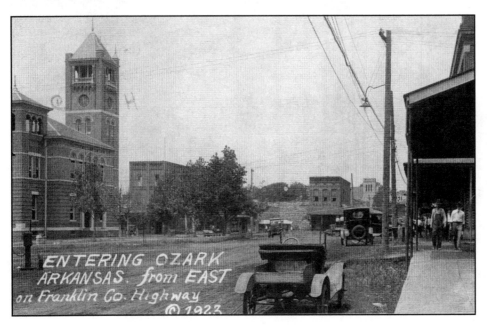

Ozark, 1923 The Franklin County seat was founded in 1837 as a port on the adjacent Arkansas River. What would become U.S. Highway 64 ran through town and was still unpaved in front of the courthouse. Most of the buildings still stand today, though with alterations.

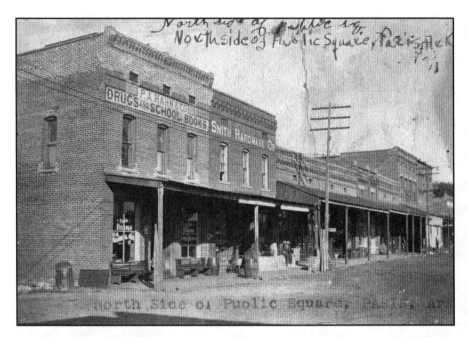

North Side of Public Square, PARIS, AR

Paris, circa 1910 and 2009

The town—named for Paris, France—was settled in the 1820s and became the Logan (then Sarber) County seat in 1874. By the time of the postcard above, the north side of the courthouse square was home to P. A. Hahn and Co., which sold drugs and school books. Neighboring Smith Hardware Co. sold push lawnmowers, kerosene lamps, and household merchandise. A century later, the block is remarkably intact and filled with merchants. Note that the brick façades have been painted. A video store in the center of the block represents technology never envisioned by the merchants of a century ago.

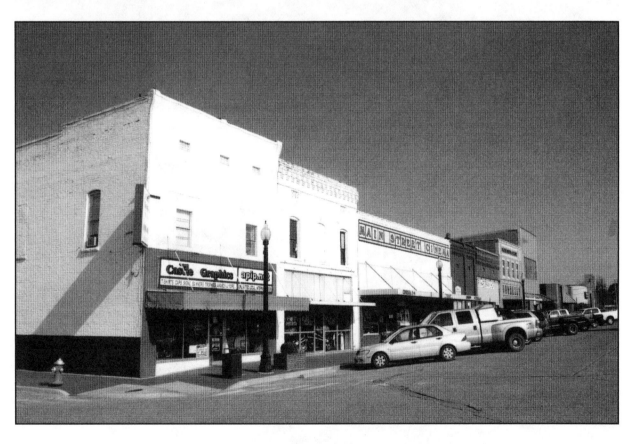

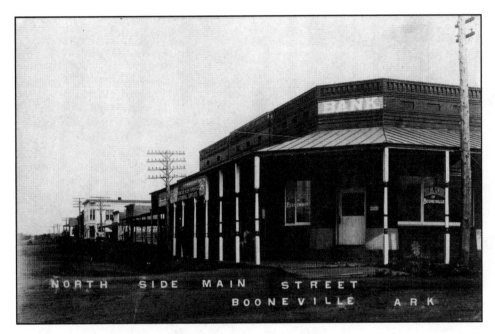

NORTH SIDE MAIN STREET
BOONEVILLE ARK

Booneville, circa 1909 and 2009 The Bank of Booneville anchored the north side of Main Street. Next door, a sign offering furniture, books, and "funeral supplies" evidences the necessity of providing several services to make ends meet in rural communities. Today, the block's corner has been tastefully restored (note the removal of the prior tin awning). First West Insurance occupies the former bank building (now painted red).

139

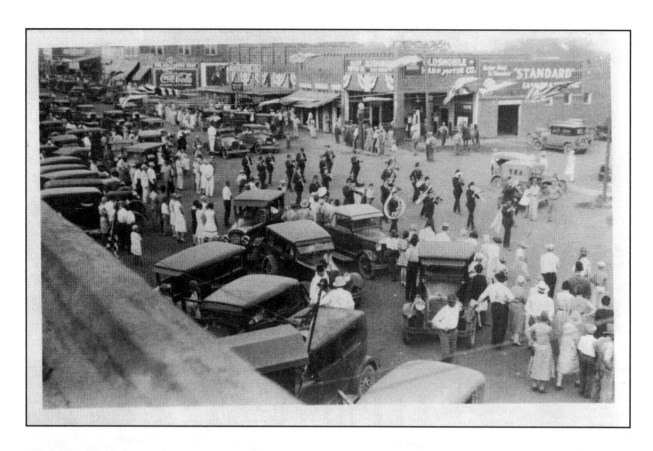

Booneville, 1930
Booneville, in Logan County, which became home to the state's Tuberculosis Sanitorium in 1910, had its major commercial center on Broadway. Above, we see Broadway a block below its intersection with Main. The occasion for the parade passing Harp's Oldsmobile dealership is lost to history, as is the Oldsmobile itself. Today, the former Harp's is home to Dunn Chevrolet, part of a largely intact and occupied several blocks of Broadway.

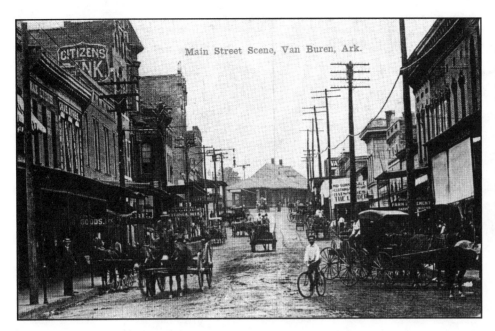

Main Street Scene, Van Buren, Ark.

Van Buren, circa 1910
The Crawford County seat, named for President Martin Van Buren, may own the claim to the finest preserved Main Street in the state. It boasts more than 70 buildings restored. The wagons are gone and the street is paved, but the view today is otherwise remarkably the same, even to the depot at the end of the street.

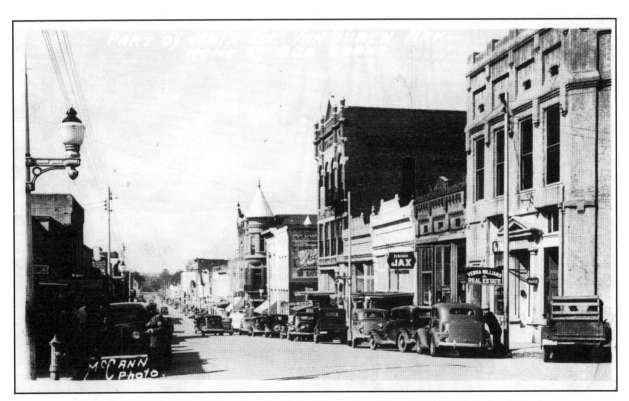

Van Buren, 1942 Verna Williams Real Estate shared a block with a tavern (advertising JAX beer) when Main Street was often crowded by troops training for World War II at nearby Fort Chaffee. The restored Main Street was used as a location for both Vicksburg and Gettysburg in the TV mini-series *The Blue and the Gray.*

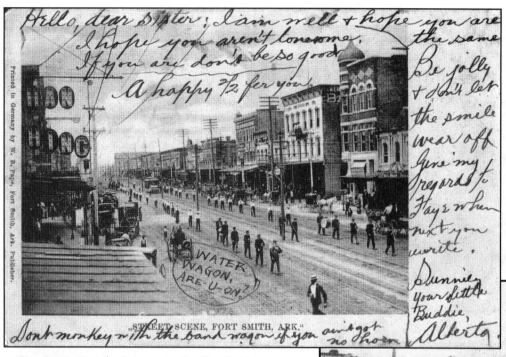

Printed in Germany by W. B. Pape, Fort Smith, Ark. Publisher.

Hello, dear Sister; I am well & hope you are the same I hope you aren't lonesome. If you are don't be so good A happy 1/2 for you. Be jolly & don't let the smile wear off Give my regards to Faye when next you write. Dunnie, your little Buddie, Alberta.

"STREET SCENE, FORT SMITH, ARK."

Don't monkey with the band wagon if you ain't got no horn

Fort Smith, 1906 As the name implies, Fort Smith was born a military outpost on the Indian frontier in 1817. Its "main street" was pre-ordained to forever be the 100-foot-wide Garrison Avenue, which once led to the fort. The long, wide avenue hosted a parade, the occasion not noted in the card's inscription.

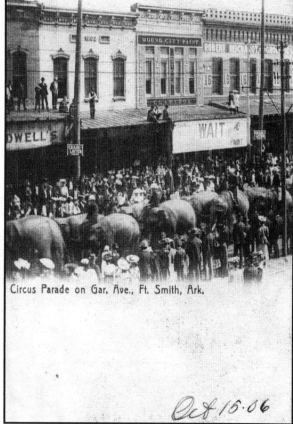

Circus Parade on Gar. Ave., Ft. Smith, Ark.

Oct 15.06

Fort Smith, 1906 The long expanse of Garrison Avenue hosted many parades over the past century, including the circus parade shown here with elephants that had come to town by train to thrill young and old alike.

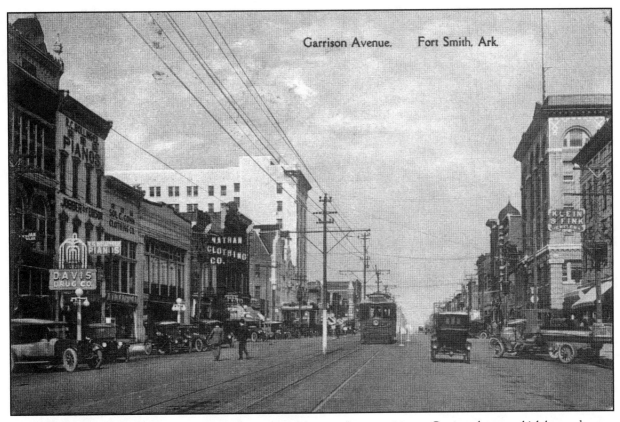

Fort Smith, 1921 "Reverse shows one of the busy streets of the town," wrote a visitor to Garrison Avenue, which boomed with commerce. Prominent merchants included Klein & Fink Jewelers to the right, as well as Sol Cohn's Clothing and Bollinger's Pianos to the left.

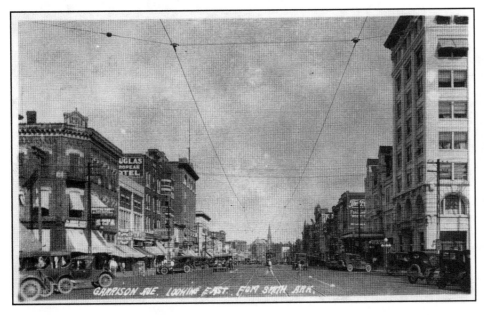

Fort Smith, circa 1925 This view looks east back toward Immaculate Conception Catholic Church, its steeple marking then, as it does today, the head of Garrison Avenue. One of the street's most striking early twentieth-century buildings, the 1910 First National Bank building (to the right) stands today, though several other buildings are now gone.

143

Fort Smith, 1933 The streetcars that had rumbled up and down Garrison rolled into history in 1933 when the city replaced them with a fleet of buses, seen here driving over the still-present tracks.

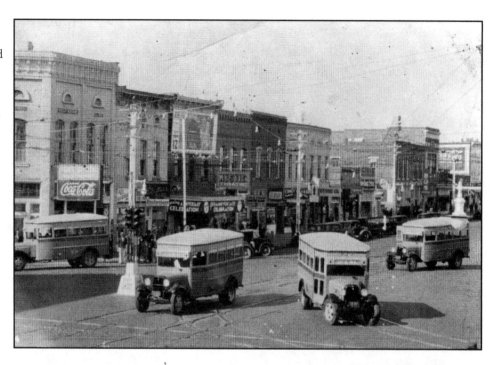

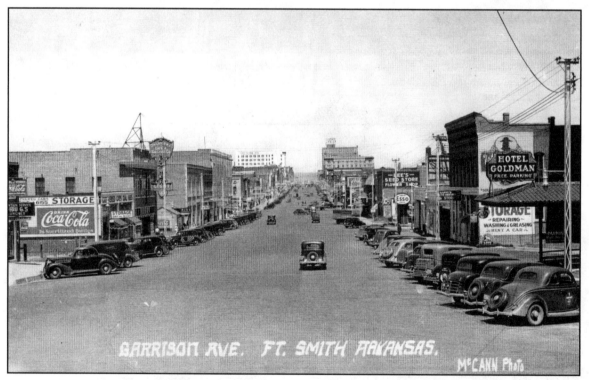

Fort Smith, circa 1935 The photographer stood at the head of Garrison Avenue, looking west toward the Arkansas River and Oklahoma. The Hotel Goldman, denoted by the sign on the right, was the town's finest; today it is a parking lot.

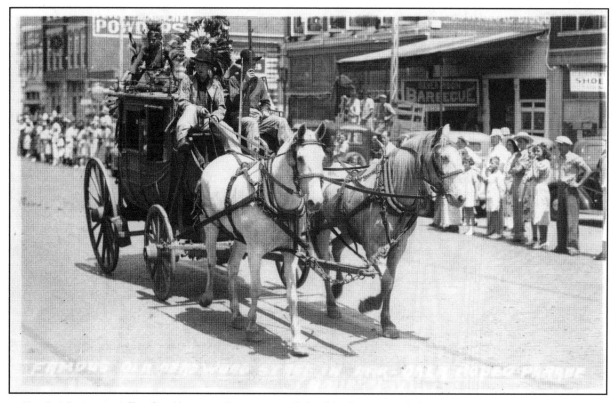

Fort Smith, circa 1945 Fort Smith's western heritage is symbolized by the stagecoach shown here, with Native Americans perched on top. The spectators at the right were standing in front of Silver Moon Barbecue.

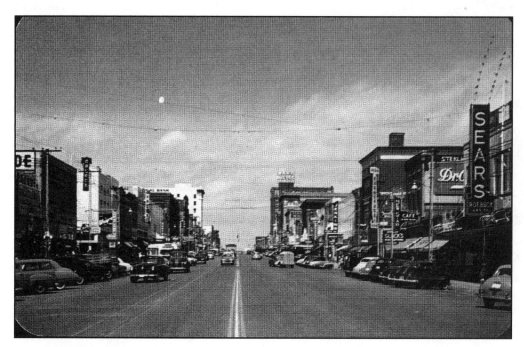

Fort Smith, circa 1950 Garrison Avenue was still the shopping magnet for the booming city on the river. Merchants on this street, including Sears (to the right), would later flee the grand street for shopping centers. The Ward Hotel towers in the distant right.

Fort Smith, circa 1960
Change was coming to Garrison Avenue, with the strikingly modern First Federal building (on right). Also, the Ward Hotel (on left) was soon to be converted to an office building. Today's Garrison Avenue, beset by decades of fire, tornados, and the wrecking ball, is hanging in the balance. It remains to be seen whether the city has sufficient civic pride to return Garrison Avenue to its former glory.

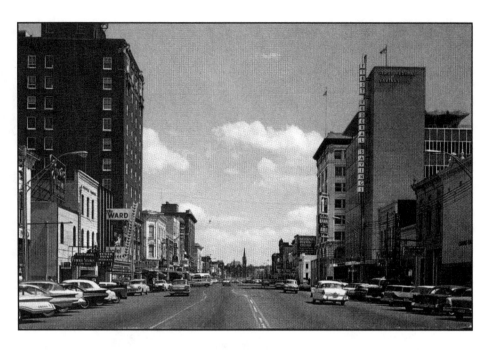

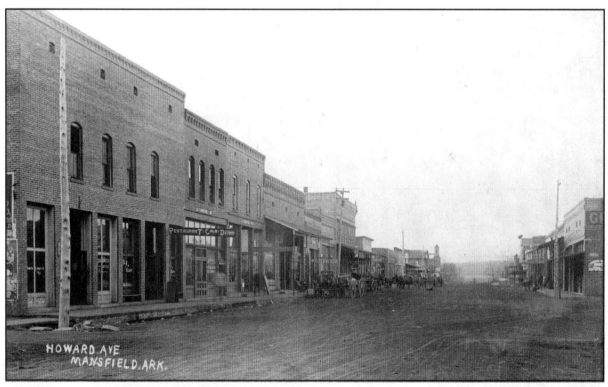

Mansfield, circa 1905 The small Sebastian County town south of Fort Smith, named for a state supreme court justice, had the good fortune to find itself the location of the state's first natural gas well, which was drilled there in 1902. The main business street was Howard Avenue, its long row of recently built brick buildings indicative of growth and prosperity.

146

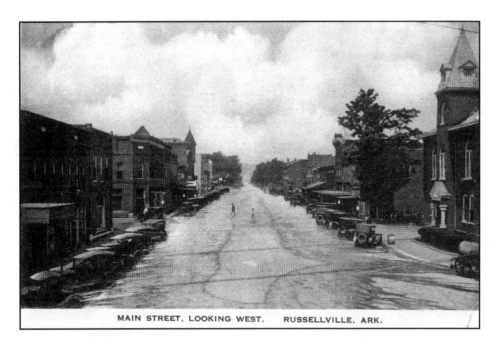

MAIN STREET, LOOKING WEST. RUSSELLVILLE, ARK.

Russellville, circa 1920
The eastern end of the Pope County seat's Main Street was anchored by its 1890s-era courthouse. Automobiles were parked in angled spaces in front of shops along the wide street. Incorporated in 1870, the town was reportedly named for pioneer doctor Thomas J. Russell.

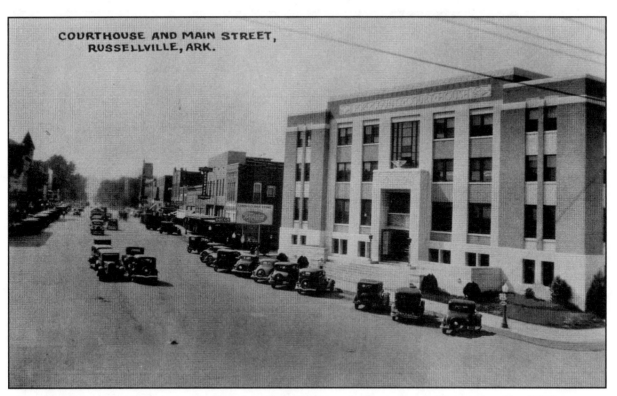

COURTHOUSE AND MAIN STREET, RUSSELLVILLE, ARK.

Russellville, circa 1935 By the 1930s, the Pope County Courthouse in the above photo had been replaced by a WPA-era building. A similar fate befell many of Arkansas's nineteenth-century courthouses.

Russellville, circa 1957
The home of (then) Arkansas Polytechnic College (now Arkansas Tech University), Russellville was a magnet for shoppers and visitors from a large part of western Arkansas. Entertainment was an important lure, too; the Main Theater (left) was a popular spot on weekend evenings. This view, looking west, still retains many of the now century-old buildings—with a very different mix of businesses in the age of shopping centers and Wal-Mart.

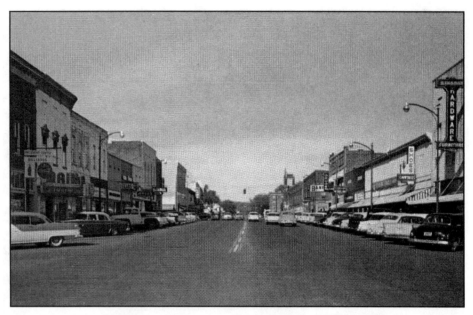

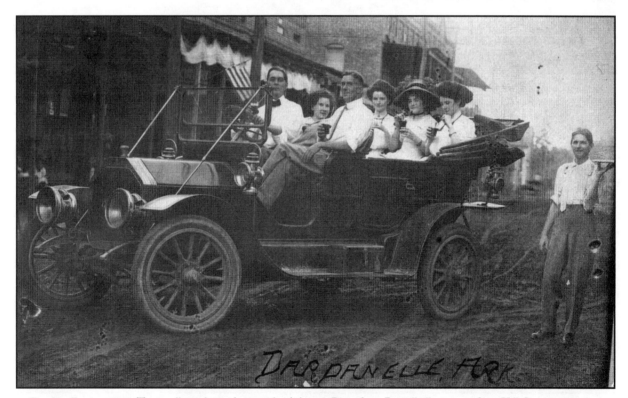

Dardanelle, circa 1910 The small city, located across the Arkansas River from Russellville, is one of two Yell County seats. Platted in 1847, the town boasted a business district that would spread out along Front Street for decades. Note a drugstore soda fountain offering curb service. Customers might have been served by the young man standing (at right) on the dirt street, balancing his tray.

148

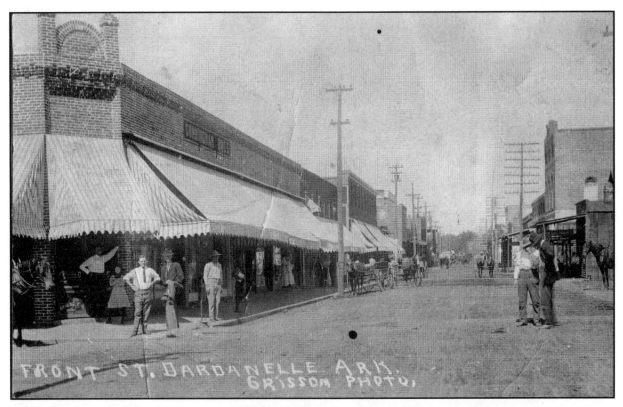

Dardanelle, 1910 Two men stand on the packed-dirt Front Street (right) deep in conversation, while to the left, a clerk poses in the entrance to Cunningham Brothers store. Today, some buildings are gone, and others have been altered almost beyond recognition. Dardanelle remains a pleasant small town.

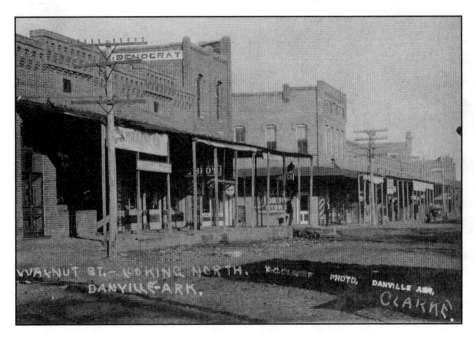

Danville, 1909 Danville, located in the western part of Yell County, shares county seat honors with Dardanelle. Its business community formed along Walnut Street. Mrs. Harrell's Millinery sign hangs over another sign, which advertises Rock Island Plows. Harrell's shares a block with the local newspaper. Very few of the buildings survive today in a town that has become a poultry-processing center with a burgeoning Hispanic population.

Plainview, circa 1910
"Auntie, this picture shows Main Street, my house is right over the cross made and my shop in the two story brick but business is certainly dull." Aunt Bell had marked the little store on the left and a house in the distance at the end of the dirt Main Street in the view of this small Yell County town.

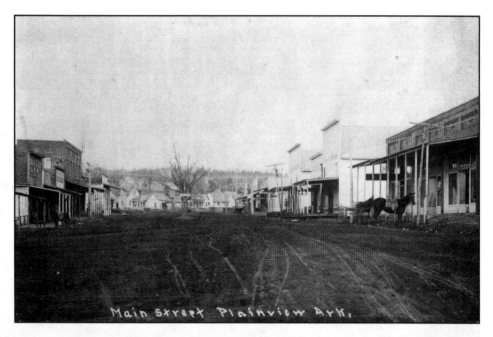

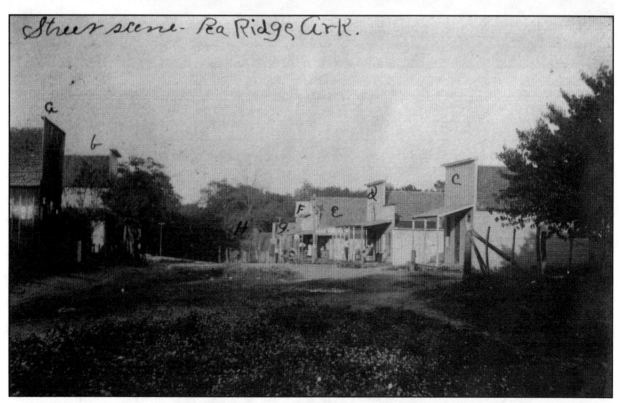

Pea Ridge, 1908 The small Benton County town had been the site of a significant and bloody Civil War battle only 46 years before its Main Street was captured in this view. The sender of the card coded the buildings with letters to match an index on the back, "a" was the blacksmith shop, "g" the livery barn, and "c" Dr. Green's office.

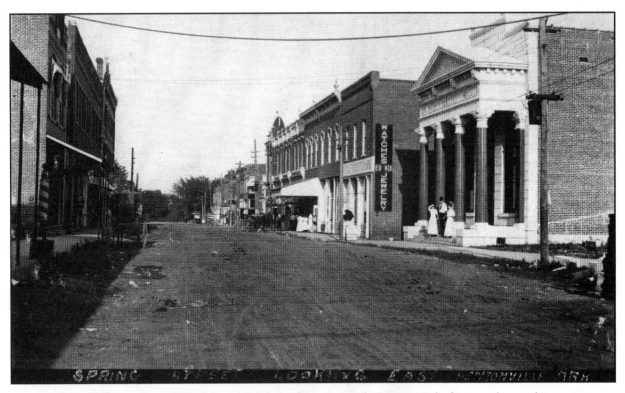

Bentonville, circa 1910 Spring Street (today called Central) was a major business artery leading into the courthouse square a block below where the photographer stood in the dirt street. The marble-columned Benton County Bank still stands, as does the rest of the block, where the Chamber of Commerce is housed today.

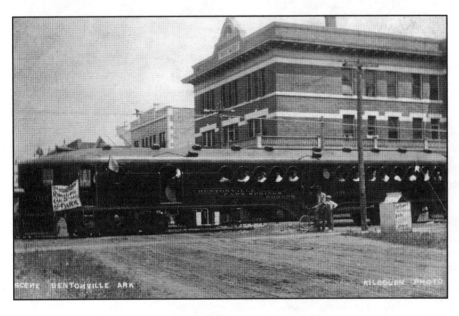

Bentonville, 1914 Spring Street (today called Central) still wasn't paved, but a most novel experiment in mass transit had come to town. The big, red "inter-urban"—with ninety-two-foot-long cars—provided service between Bentonville and Rogers. It picked up passengers along the way for a 15-cent fare. The venture lasted two years, folding in 1916 when its bankrupt owners could no longer pay for the use of the track. The Hotel Massey, rising behind the inter-urban, still stands. Today, the former hotel is a temporary home to the Crystal Bridges Museum of American Art until construction of the permanent home is complete. It also houses the downtown branch of the Benton County Library.

Rogers, circa 1905 The Benton County town, incorporated in 1881 and named for the general manager of the Frisco Railroad, had a population of more than 2,000 at the time of this postcard. The Saturday crowd packed Walnut Street, the main business avenue. Part of the building to the left housed T. J. Keller's Hardware & Harness store, whose banners also advertised groceries and livestock feed.

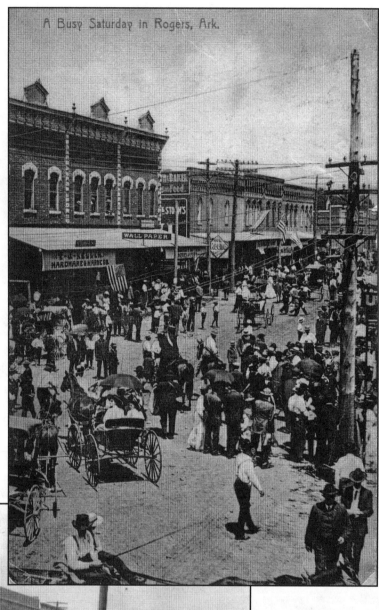

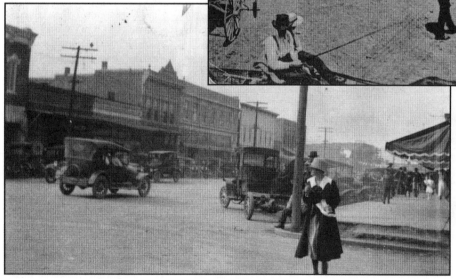

Rogers, circa 1920 By the time this fashionably dressed lady was carefully making her way across the street, Rogers's population had swelled to 3,300.

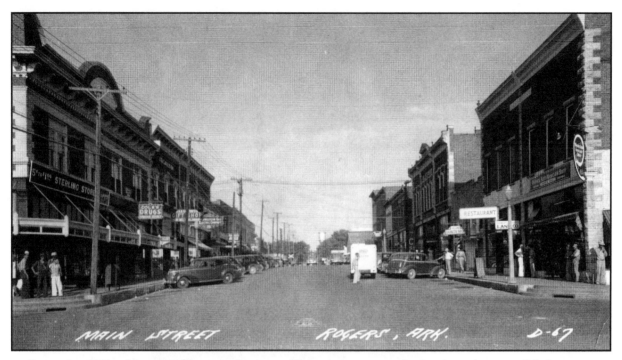

Rogers, circa 1945 and circa 1960 These two views, some 15 years apart, capture what is today perhaps one of the best-preserved buildings on historic Walnut Street. Erected in 1909 as the Elks lodge building, it was later home to an Arkansas Main Street icon, Sterling, shown in both postcards. By 1960, Western Auto had moved from the left-hand corner to share the block with Sterling. Sterling and Western Auto are gone today, but Walnut Street is a fabulous example of a preserved, vibrant downtown, even retaining the brick pavement.

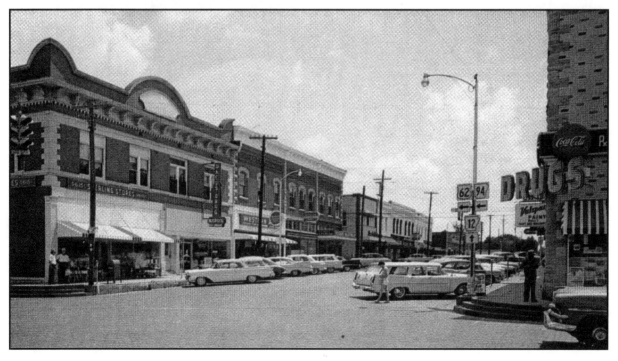

Siloam Springs, circa 1910
The resort town, named for the biblical Pool of Siloam, developed most of its business district along Broadway and St. Nicholas avenues. Mattie Vanhooser, here greeting mail carriers in their buggies, was the city's first female postmaster, serving from 1910 to 1914. The post office was located on St. Nicholas.

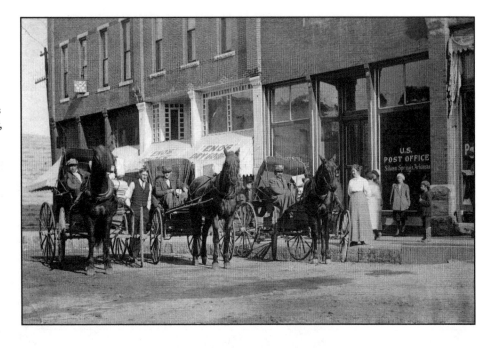

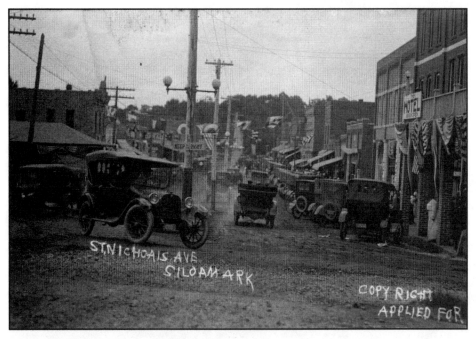

Siloam Springs, circa 1918
The photographer stood at the head of Broadway looking into the heart of the business district. The nearest car was making a turn off the dirt street onto St. Nicholas (today University Street). The street was divided by a line of utility poles—a sign affixed to one reads "keep right." The poles are gone today, the street is paved, and the top floor of the hotel to the right is gone, but the area along Broadway is one of the best-preserved, most vibrant downtowns in modern-day Arkansas.

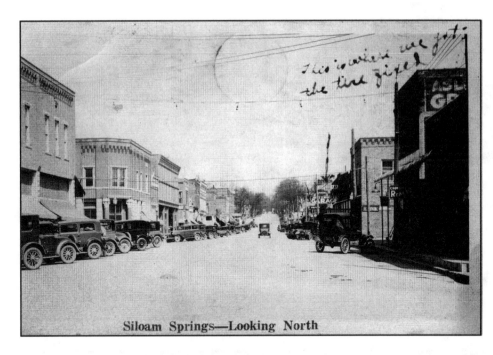

Siloam Springs—Looking North

Siloam Springs, 1929
"This is where we got the tire fixed," wrote a couple from Kansas City who had visited Broadway. Today, almost all the historic buildings survive, several as antique and coffee shops. Siloam Springs's downtown owes its prosperity, in part, to nearby John Brown University.

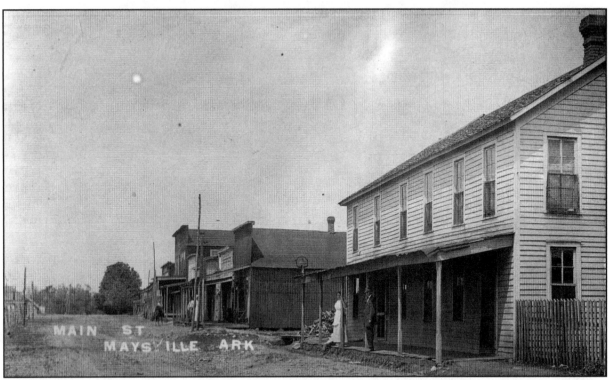

Maysville, circa 1910 The tiny town in western Benton County is almost on the Oklahoma state line. The first store opened in 1839, making a profit by selling whiskey to the Native Americans, according to J. Dickson Black writing in *History of Benton County*. This postcard captured the short business district of wood-frame stores lining the dirt Main Street. All are gone today.

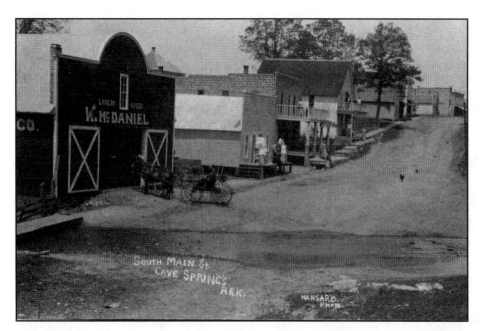

South Main St. Cave Springs, Ark.

HANSARD PHOTO.

Cave Springs, circa 1910
A cave from which a spring flows gave the town its name. At the time this photo was taken, the surrounding area was planted with apple orchards, their apples being shipped by rail from Cave Springs. A visitor riding onto Main Street from the south would have perhaps stopped first at McDaniel's Livery. Today, a few of the historic native stone buildings survive, as do the spring and small lake it formed.

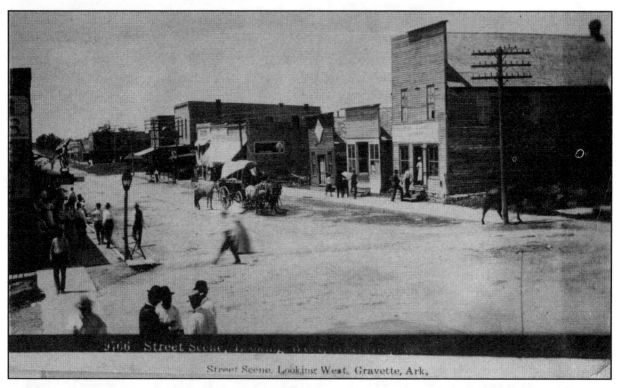

Street Scene, Looking West, Gravette, Ark.

Gravette, circa 1905 E. T. Gravett, owner of a local distillery, built a store on the new rail line and laid out a town upon which he bestowed his name in 1893. (No one is sure how the town got the extra "e" at the end of its name.) On the day the postcard photo was taken, a covered wagon was making its way into a town crowded with commerce, including four men deep in conversation at the lower left.

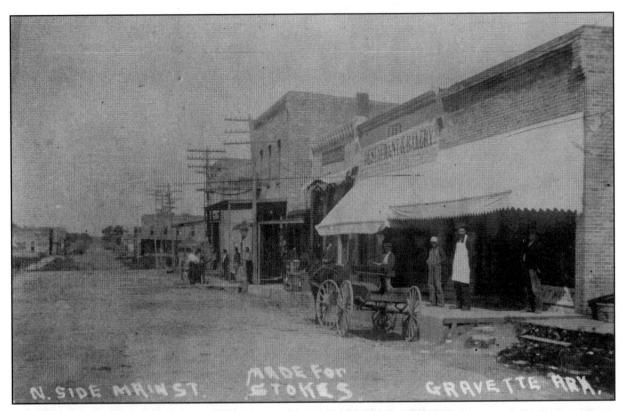

Gravette, circa 1910 The photographer focused on the north side of Main, capturing buildings present in the photo on the previous page. The man on the sidewalk dressed in the apron likely had just stepped out of the City Restaurant and Bakery. A bank occupied the building next door, while in the distance, a hotel also faced the dusty street.

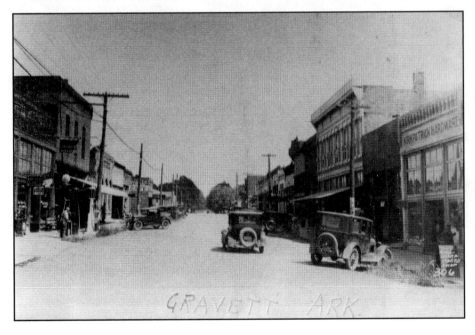

Gravette, circa 1930 The view looked at the north side of Main from the opposite direction of 20 years earlier, but the tallest building from 1910 was still present (this time on the left). A Chevrolet dealership was operating next to it, selling gas from gravity-fed pumps mounted on the sidewalk. Just down the block, a barber shop was operating in what had been the bakery two decades earlier. Today, most of the historic buildings survive, though some have been altered as the street has struggled for a retail presence in competition with shopping centers.

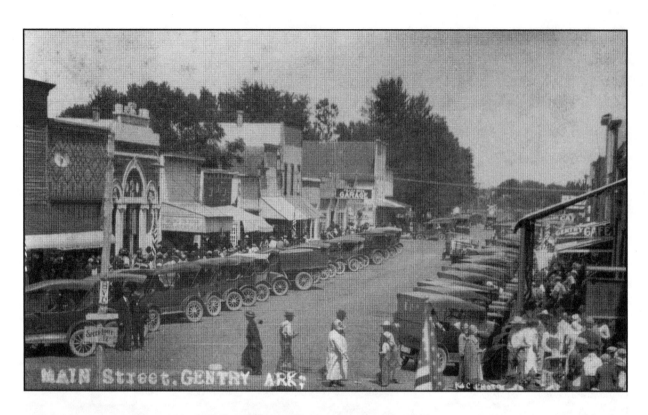

MAIN Street. GENTRY, ARK;

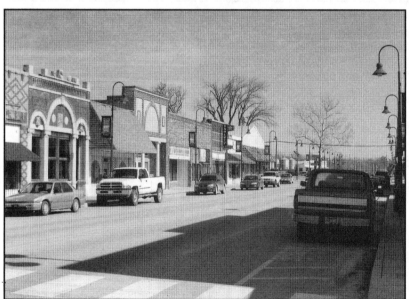

Gentry, circa 1918 and circa 2009
The American flag seen in the lower right of the top photo suggests that Main Street may have been crowded on some patriotic occasion as World War I was raging in Europe. The note on the back of the card focuses on the rather large lady crossing the street in the center of the photo. "After living here a while, the life is not so simple as you see these are not oxcarts nor wagons. The fare is not so bad as you will observe the lady in white, who is crossing the street. She is not especially thin. I make haste to say it is not me. Altho both C.F. and myself are now what is termed 'stout.'" Note the sign "bring us your eggs and chickens" and the 12 MPH speed limit. Today, as seen in the 2009 photo from the same vantage point, the street's brick and stone buildings still stand; the wooden-frame ones in the 1918 photo do not. Most striking is the Bank of Gentry building to the left, immaculately restored.

INDEX OF TOWNS

Osceola, 2009 Storefront on Hale Avenue, the town's main street.